c. 1900 Visual structure reigns supreme in "Still Life with Apples and Oranges," as Paul Cézanne creates a pyramidal composition from a patchwork of "color planes." Warm, red-orange hues seem to advance, while cool, blue-green tones recede.

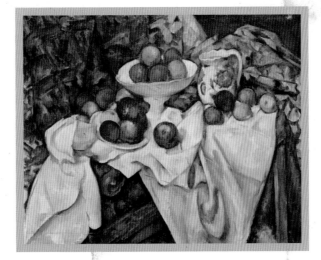

THE ILLUSTRATED TIMELINE OF
Art History

THE ILLUSTRATED TIMELINE OF
Art History

A CRASH COURSE IN WORDS & PICTURES

Carol Strickland, PhD

A JOHN BOSWELL ASSOCIATES BOOK

STERLING PUBLISHING CO., INC.

NEW YORK

Library of Congress Cataloging-in-Publication Data Available

2 4 6 8 10 9 7 5 3 1

Published by Sterling Publishing Co., Inc.
387 Park Avenue South, New York, NY 10016
© 2006 by Sterling Publishing, Co., Inc.
Distributed in Canada by Sterling Publishing
c/o Canadian Manda Group, 165 Dufferin Street
Toronto, Ontario, Canada M6K 3H6
Distributed in the United Kingdom by GMC Distribution Services
Castle Place, 166 High Street, Lewes, East Sussex, England BN7 1XU
Distributed in Australia by Capricorn Link (Australia) Pty. Ltd.
P.O. Box 704, Windsor, NSW 2756, Australia

Printed in China

Sterling ISBN-13: 978-1-4027-3603-2
ISBN-10: 1-4027-3603-7

For information about custom editions, special sales, premium and
corporate purchases, please contact Sterling Special Sales
Department at 800-805-5489 or specialsales@sterlingpub.com.

Book Design by Barbara Aronica-Buck

Contents

Acknowledgments

Many thanks to John Boswell, Christa Bourg, and Lauren Galit, who originated this project and worked diligently to bring it to fruition. My gratitude also to Barbara Aronica-Buck for her superb design skills in making so much information visually appealing. The team at Art Resource provided high-quality images with great professionalism, as did several artists and our illustrator Luci Betti. The Sterling crew helped with conscientious fact-checking and copyediting. I apologize in advance to the many outstanding artists whose works we could not include in this brief survey, in some cases because images of their works (or permission to reproduce them) were unavailable.

Members of my nuclear family—Sid, Eliza, Alison, Joe, and Lora—were an unfailing source of support and delight during the production of this book. And my extended family supplied constant enthusiasm to keep me going forward through the march of time. Since this is a timeline, I want to especially thank my brothers, John and Wade Colclough, who've been with me longest during my time on earth. May time be kind to them, and may my beloved city of New Orleans rise from the mud!

Introduction

Why should you care about the history of art? Well, for as long as human beings have been capable of symbolic thinking, they've been making art, reflecting humanity's highest aspirations, skills, and creativity. Art's goal can be said to be communication or expression, a way of interacting with and trying to make sense of the world. All art grows out of a specific climate and culture, giving expression to the ideas and emotions of a particular time and place. In this way, the history of art encapsulated in these pages is a diverse pageant of human civilization. It's a tangible record of the human mind and spirit, helping us to understand where we came from, as well as to foresee where we might be headed.

The goal of this book is to make looking at art more than just a spectator sport. This highly condensed survey of art history will help you to look at and analyze works of art as well as inspire you to want to know more. With the tools and information provided, you will become an active responder when confronting an artwork that is trying, sometimes mysteriously, to tell you something. Dialogue with a masterpiece can result in discovery, revelation, even exhilaration. And a work of art is not complete until the viewer himself completes it through his own creative response.

Included in this book are examples of great and influential artworks throughout history, beginning in the prehistoric era, about 24,000 B.C., and continuing through the end of the twentieth century. *The Illustrated Timeline of Art History* thus serves as an overview, in words and pictures, of artistic achievement over a span of twenty-six millennia. Leonardo da Vinci was convinced that to "see" and to "know" are virtually the same. This book will help readers know art through seeing a cavalcade of images, sculpture, and architecture by the world's most celebrated artists.

The art in this book is arranged in timeline

format, which is to say, in chronological order. Not only does this format allow you to scroll quickly through a vast visual trove of art history, it also makes it easier to trace the evolution of artistic schools, movements, and trends. Overall, this survey of art reveals certain recurring swings of the pendulum: from art that describes the external world objectively to art that is subjective, more like abstracted invention than reproduction. Charting changes in technique, subject, theme, and style shows both continuity and revival, as well as reaction and rebellion against prevailing principles.

In art we see progression, but we can't call it "progress." Although different approaches wax and wane through the centuries, one style is never intrinsically better than another. It's only fair to say it's different, and personal taste supplies the ranking.

How to Read This Book

The vast breadth and span of material covered in this book is divided up into four major sections, each with its own introduction. To help you understand the bedrock from which the works in each section spring, these introductions supply background information about the socio-political state of the world at the time the art was created. They provide a context covering artistic movements, technological changes, theological concerns, and political upheavals, which artists reflect in their work.

Artworks are then shown in the timeline format, each accompanied by a text entry that focuses on the work's particular importance in the development of art. The entries vary, from giving hints on what to look for in a particular painting to a succinct statement of an artist's main innovation or contribution to the history of art. Sometimes the key to a work of art involves an appreciation of its content or message. Other times, it entails an understanding of methodology—how the theme is expressed.

In addition, entry texts are color-coded to tell you, at a glance, where in the world a particular piece was made. Sidebars are scattered throughout the book to provide more details about major movements, breakthroughs, or individual artists, thus deepening your understanding of the works you see before you.

This highly browseable, visual presentation will help you understand and enjoy the world of art, whether the book serves as an introduction or just a refresher course. Regardless of your past experience with the subject, you'll surely be delighted to see so many works of outstanding quality and significance collected in one place. The artist Vincent van Gogh wrote in his last letter before he died, "The truth is, we can only make our pictures speak." Seeing these pictures, one hears the voices of great individual talents and the collective song of their times.

Caption Color Key

= Europe

= North America

= Asia

= Africa

= South America

= Australia

Art Starts: From the Prehistoric Era to the Middle Ages

Thirty thousand years ago, prehistoric beings produced an abundance of art—statuettes, animal figures, cave paintings, and then giant arrangements of standing stones—to give physical form to abstract ideas. These embryonic expressions of art used ivory, stone, pigment, and later ceramics in an attempt to influence supernatural powers. Stone Age art was a means to harness magic. Seasonal change, the hunt, the animal world, ritual, and fertility are its themes, inspired by both fear of predators and natural cataclysms and longing for a secure, even transcendent, life.

When the Ice Age ended around 10,000 B.C.E., people emerged from caves, domesticated plants and animals, and changed from hunter-gatherers to farmers. They began to settle down in organized communities.

Civilization was born roughly five thousand years ago along the banks of the Nile in Egypt and in the fertile crescent between the Tigris and Euphrates rivers, which the Babylonian king Nebuchadnezzar called "the navel of the world." Along the Yellow River in China and in the Indus Valley, sophisticated cultures were also developing.

With surplus food made possible by the agrarian revolution, people had more time to devote to pursuits other than basic survival.

A class of specialist artisans developed, which flowered into the production of arts and crafts. Larger populations along with cities and social hierarchies emerged, and the art of these cultures served deities and glorified rulers, as well as satisfying an innate aesthetic sense and yearning for beauty and adornment. In Egypt, representations followed stiff, official canons in a quest for permanence, while in Mesopotamia images were more naturalistic and warlike—a form of swagger.

In Africa, China, the Americas, and Australia, artists were also creating art as magic charms and emblems of gods, kings, and myths. Church and state were the poles that visual culture served in constant oscillation.

With the Greco-Roman art of Classical antiquity, beginning around 500 B.C.E, eyes turned to mankind and the material world. The goal was imitation of surface appearance, as seen in pottery, murals, mosaics, and sculpture. Greek sculpture, while naturalistic in pose and form, was idealized, in harmony with Greek ideals of balance, beauty, and a democratic respect for the individual. Rigid, archaic forms gradually gave way to a free rendering of the human figure in movement, yet permeated by Olympian calm. Hellenism (which spread Greek culture over the twenty thousand miles

conquered by Alexander the Great) elaborated on this base. But Hellenistic art tipped the scale from serenity toward frenzy and drama.

Romans perpetuated this heritage, with their own twist. Both pragmatic and arrogant, Romans added realism in portraiture and majestic scale in architecture. They achieved great feats until Rome fell to the Visigoths in 410, effectively ending the art of antiquity.

In 391, Christianity became the official religion of the Roman Empire, centered in Constantinople. The interests of church and state became identical. Instead of realism, etherealism dominated.

Byzantine art of the Middle Ages merged imperial glory with Christian motifs, full of mystery and symbols, as if all eyes should be on the firmament. Art was dehumanized, bent to religious objectives. Rules prescribed strict artistic conventions with gesture, setting, and pose all pregnant with meaning. As interest in the body and the world plummeted, figures were shown in frontal, static stances more heraldic than human. They seemed to float, divorced from the real world, as if portrayed on a cloud.

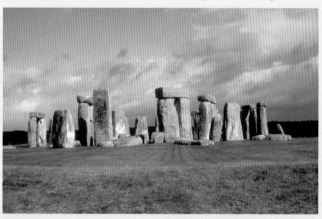

When the widely-predicted end of the world failed to arrive after 999, a wave of church construction signaled ardent faith and new prosperity in the rapidly growing towns of Western Europe.

The Romanesque style of this epoch was characterized by solid, chunky buildings and solemn sculptures imbued with the passion of martyrs—who were often its subjects. Teaching Christian doctrine remained the main function of art.

During these feudal times, the church was a bastion of security. Obedience was mandatory for God's protection against ills like the plague, constant sieges, and warfare. As feudalism diminished, nation-states grew in Europe, trade increased and minds broadened through travel. Stylized images gradually became more human. Portrayals of both figure and setting became more realistic. Pattern, rhythm, dynamic lines, and vivid color appealed to the senses.

Gothic art was still mainly linear, but knowledge of anatomy and experiments with perspective increased. Churches used stained glass to adorn walls, which became thinner and higher. The Byzantine focus on divinity and the Romanesque stress on austere spirituality evolved into more natural portrayals.

The pattern of art in these periods fluctuated between attention to this world and to other-worldly ideals. Throughout early history, art was used to preach, teach, and reach for the stars.

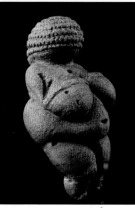

24,000–22,000 "Venus of Willendorf," with bulbous breasts, abdomen, and featureless head covered by zigzag braids, is perhaps a goddess or fertility symbol. Carved from limestone, 4 ⅜ inch figure originally painted with red ocher.

c. 5000 Earliest images appear in Africa. (Stones painted and incised in charcoal, blood, and ocher date back to 100,000 B.C.E.) Rock painting from Tanzania shows trance dance performed by shaman. Rhythmic singing, clapping, intense dancing induce mystic revelations of spirit world.

2710–1500 Stonehenge: probably solar observatory. Concentric circles of massive stones, the largest ring 97 feet in diameter. Outer ring of monoliths capped by horizontal slabs. Inner circle surrounds horseshoe of five lintel-topped pairs of stones weighing up to 50 tons. Outer heel-stone marks sunrise at summer solstice.

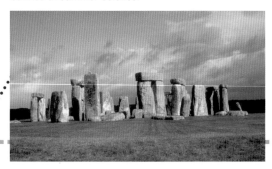

24,000 BCE

5000 BCE

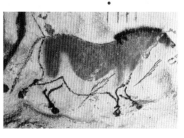

15,000–10,000 Cave painting called "Chinese Horse," since it resembles ink-brush paintings. Subtle tonal variations show prehistoric artists' skill. Thousands of animals' images such as bison and deer cover cave walls, use protruding rock for 3-D effect.

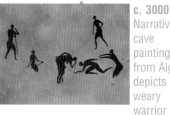

c. 3000 Narrative cave painting from Algeria depicts weary warrior returning from hunt. Two figures move to help as he collapses. Unlike cave paintings in Spain and France portraying mainly animals in profile, later paintings on rock shelters show groups of human figures, may record actual events.

Stone Age Art: Magical Realism

30,000 years ago, Cro-Magnons in Europe create thousands of cave paintings, etchings on cave walls, and sculptures carved from ivory, antlers, or stone. The paintings capture figures in bold outlines and energetic poses. The images are superimposed in multiple layers, suggesting a ritual, not decorative, function. Since most paintings are located far from an entrance, they probably mark sacred sites.

2600 Six-tiered step pyramid, originally faced in fine limestone, oldest of Egypt's 97 pyramids and first tomb built entirely of stone. Architect Imhotep designs it for King Djoser's monument, crowning underground burial chamber.

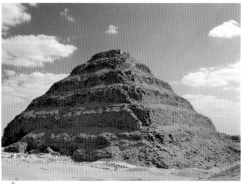

Pyramid's interior includes incomplete burial chambers (1, 2) and final chamber (3), reached through Grand Gallery (4), ventilated by air shafts (5, 6). Ascending Corridor (7) sealed from within by stone plugs, then workmen escape down shaft (8) and out through Descending Corridor (9).

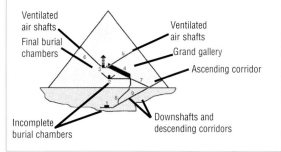

Ventilated air shafts

Final burial chambers

Ventilated air shafts

Grand gallery

Ascending corridor

Incomplete burial chambers

Downshafts and descending corridors

Egyptian Art: For All Time

During the Old Kingdom, Egyptian architects build colossal stone structures, and sculptors produce portrait statues, developing the first consistent styles in art. Precisely detailed images of animals and plants are painted and carved on the walls of tombs and temples. Their purpose: to assure eternal life after death, to appease the gods, and to influence nature. For 3,000 years, Egypt's repertory of images is limited to prescribed forms.

c. 2580 Three pyramids of Giza outside Cairo intended to preserve and protect remains of pharaohs throughout eternity. Pyramid shape most stable known. Largest, Khufu's pyramid, originally 481 feet high, covers 13 acres. Stone blocks 2–5 feet high once covered with polished granite to dazzle eyes like rays of light.

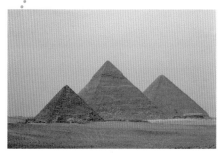

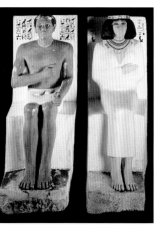

c. 2580 Lifesize, painted limestone sculpture of Prince Rahotep and wife Nofret shows typical stiff, frontal pose of Egyptian statues, suggesting stability, order.

c. 2500 Multi-tiered temples in Mesopotamia, called ziggurats, represent mountains or heavenly habitat of Sumerian gods. Ziggurat at Ur rises 70 feet above base of 200 X 150 feet. Core of mud-brick protected by skin of glazed bricks with different colors on different levels. Ramps give priests, king access to peak.

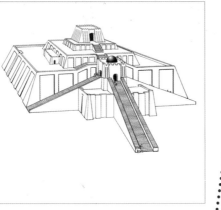

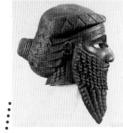

c. 2300 Akkadians display new creativity and naturalism in bronze bust of Sargon I of Nineveh. Artist's task: to glorify sovereign.

Walls of Jericho

One of the oldest inhabited cities in recorded history, Jericho is a green oasis of palms in a sea of desert. The city dates back more than 10,000 years. The oldest walled town, from 7,000 B.C.E., it has fortified, mud-brick walls. Jericho also boasts the oldest 12-foot stone walls, the oldest stairs in the world, and a 20-foot-high tower. According to the Bible, the walls of Jericho tumbled to the ground 3000 years ago after priests blew their trumpets.

2500 BCE

2300 BCE

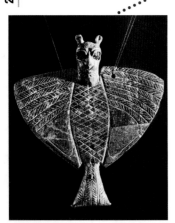

c. 2400 Pendant of hammered gold, with sheet-gold head of lion and lapis-lazuli wings of eagle worn by high official in city of Ur. Fine jewelry shows skillful metal-lurgy and finesse in carving. Found in royal tomb, evidence of refined craftsman-ship in Mesopotamia.

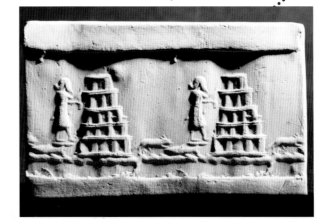

c. 2000 Babylonian seal shows ziggurat and priest. Moon god believed to dwell in shrine at top of ziggurat. Size and solidity of structure indicate awesome power of city-state and king.

2000 Alignments of standing stones (called *menhirs*) in Carnac, France probably erected over time for religious or astronomical rituals. More than 3,000 giant stones, hewn from granite, some in circles, some in parallel rows. Tallest stones 20 feet high, like procession of giants.

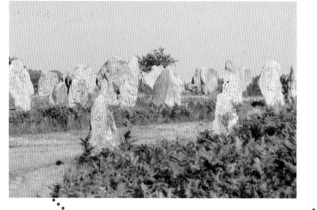

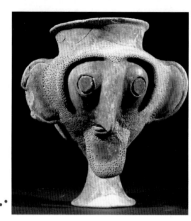

c. 1900 Art of pottery advanced in city of Jericho on River Jordan. Terra-cotta jar shaped like human head from Jericho reflects originality, concern for aesthetics.

2000 BCE

1500 BCE

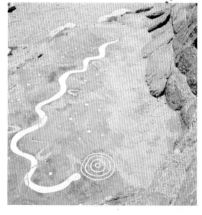

c. 2000 Mystical serpent, a totemic figure in aborigine legends. Cave paintings in central Australia record myths from "Dreamtime," the era of creation. Brush made from chewed bark used to paint with red, yellow ocher, charcoal, white clay.

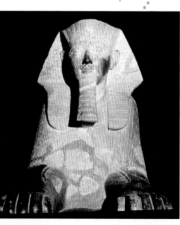

1490 Queen Hatshepsut, first female to take title of pharaoh, commissions sculpture of herself as sphinx, outfitted in king's regalia. Sphinx has body of lion and head of king, symbolizing power and might, guarantor of celestial order. One of six colossal granite sphinxes near her funerary temple. Hatshepsut undertakes hundreds of construction projects during 20-year reign. Innovation: her graceful mortuary temple integrated with landscape, rises in symmetrical, colonnaded terraces built into cliff.

7

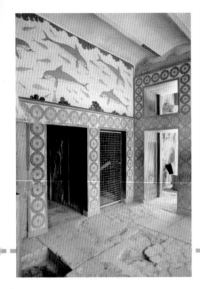

1450 Minoan urban civilization in Crete centers on rambling palace at Knossos, which has so many rooms, it's memorialized as Labyrinth of Minotaur. Queen's Chamber shows marine fresco full of joyful movement—sharp contrast to stability of Egyptian art. Palace contains first bathtub.

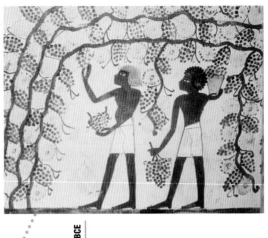

1421–13 Genre painting of everyday scenes, such as gathering grapes from arbor painted on tomb wall in Thebes, have more grace and freedom than typically restrained Egyptian art. Painting—pictographic and stylized—generally subordinate to stone sculpture and architecture. No perspective; images float in two dimensions, background implied by horizontal band above main figures.

1400 BCE

Minoan Art: A Lost World

Early art on the isle of Crete is animated and decorative, its Mediterranean verve a departure from the humorless gravity of Egyptian or Mesopotamian motifs. Its subjects are secular with abundant marine and floral motifs. The elegant, graceful objects express freedom and individuality of style. Minoan architecture is open and luxurious, with distinctive mushroom columns tapering from top to bottom.

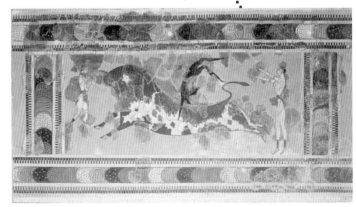

1400 "Toreador" fresco from Knossos palace reveals new dynamism in art. Scene portrays female athletes in stages of leaping over bull's back.

8

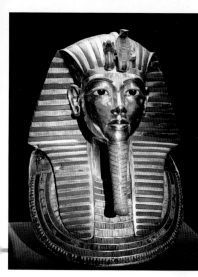

1342 Pharaoh Tutankhamen's mummy, unearthed in original state, concealed by beaten-gold mask. Crown composed of vulture and cobra, emblems of Upper and Lower Egypt. Tomb artifacts of unparalleled craft.

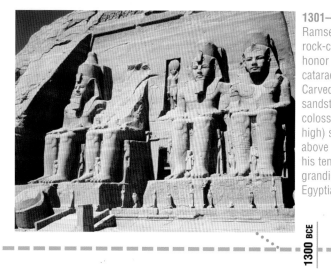

1301–1260 Ramses II orders rock-cut statues to honor himself at first cataract of Nile. Carved from sloping sandstone, four colossal (65 feet high) statues sit above entrance to his temple, show grandiosity of Egyptian art.

1300 BCE

1340 Bust found in house of court sculptor represents Pharaoh Akhenaten's wife Nefertiti. During his unorthodox reign, new sense of freedom and realism in arts temporarily triumphs over prior immobility.

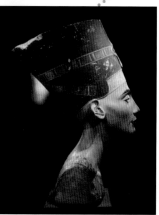

Column Styles

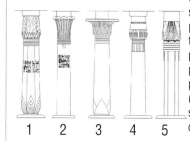

1 2 3 4 5

The earliest Egyptian houses are made of wood, thatch, and native plants. After stone construction develops, allusions to plants continue on column shafts and their capitals. (1) This column resembles papyrus reeds, (2) a tree-trunk pillar with palm leaves, (3) a stylized papyrus flower, (4) a papyrus bud, (5) a lotus flower. Forests of columns support halls, and peristyles and are covered in painted low reliefs.

Glory of Babylon

From the reigns of King Hammurabi to Nebuchadnezzar, Babylon is the cultural capitol of Sumer, progressively beautified over 1000 years. The Tower of Babel (c. 560) is only one part of a large architectural complex. It rises 300 feet, the highest ziggurat of all and wonder of the ancient world. The ziggurat is faced with glazed brick in red, blue, and yellow and adorned with reliefs of hybrid animals like gryphons. Nebuchadnezzar's mandate to his architects: "raise the top of the tower that it might rival heaven."

742–706 Sargon II's citadel surrounded by turreted walls, is a huge complex of buildings including 1.5 miles of alabaster and limestone reliefs on walls to illustrate the Assyrian king's conquests.

c. 645 Assyrian palace in Nineveh decorated with reliefs of royal lion hunts to flaunt the king's valor. New elements: drama and sense of mass and volume, even though shallow relief. Powerful forms, precise execution in realistic detail.

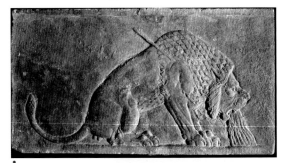

1250 BCE

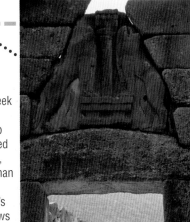

1250 Mycenaean palaces on Greek mainland are fortresses atop hills surrounded by stone walls, more blocky than airy Minoan versions. Lion's Gate arch shows two lionesses beside heraldic column carved in relief over doorway. Alert bodies guard portal.

1000 BCE

c. 575 Broad walls, wide enough "for a four-horse chariot to turn," Herodotus writes, surround Babylon. Ishtar Gate, faced with enameled blue brick and golden images of bulls and dragons, guards entrance to city. Processional way 80 feet wide, paved with pink marble and limestone, runs between 4-story walls decorated with enameled lion frieze.

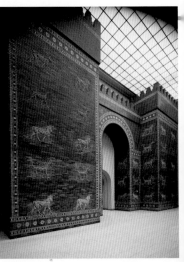

540 Black-figured vase painting features black silhouette painted on vessels against background of red clay, details scratched with needle. *Kylix*, or Greek wine cup, appropriately adorned with figure of Dionysus, his curved boat adapted to circular form of goblet.

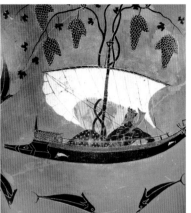

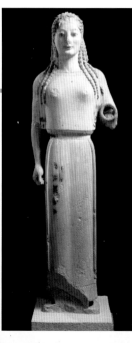

c. 480 Jades, like dragon pendant, of late Zhou period are the finest ever made, aesthetically and technically. Care lavished on China's most precious material results in complex but graceful design. Curving form of dragon, pierced, carved, and polished with virtuoso skill, expresses coiled energy.

500 BCE

450 BCE

c. 530 *Kouros* (statue of an adolescent male) and this standing female *kore* from Athens' Acropolis follow Archaic Style of rigid, frontal pose, usually with fists clenched at sides, one foot advanced, and incongruous grimace.

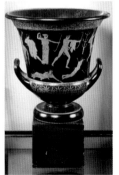

455–450 In red-figured vase, figures are left red and the background and details are painted. More precise, fluid lines drawn with brush to express emotion. On this vase, the gods Apollo and Artemis slay the children of Niobe, illustrating a Greek myth.

The Greek Way

"Wonders are many on earth, and none is more wonderful than man," Sophocles sums up the Golden Age of human artistic achievement in Athens from 480–431 B.C.E. The Greek philosophy of "moderation in all" produces sculpture and architecture of surpassing beauty, setting the paradigm in the West for millennia. The Greeks develop systems defining ideal proportions for buildings and sculpture, with all parts harmoniously unified.

11

Plan of the Acropolis

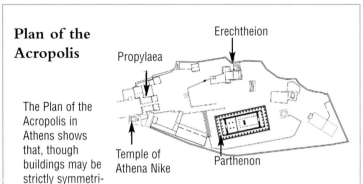

The Plan of the Acropolis in Athens shows that, though buildings may be strictly symmetrical, their placement in the ensemble of ceremonial buildings is irregular and site-dependent. Each building is considered a unique sculptural unit. Experiencing them is left to the discretion of the individual rather than dictated by one rigid, processional path. This idea incorporates the concepts of freedom and self-determination dear to Athenians in the age of Pericles.

Plan of Parthenon

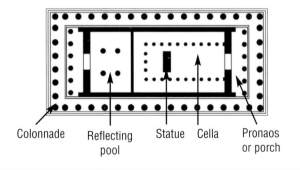

Colonnade Reflecting pool Statue Cella Pronaos or porch

448–432 Architects Ictinus and Callicrates create Parthenon as zenith of Classical Doric style, hone refinements for impression of order, harmony, clarity. Designed with perfect proportions, balance of architecture and sculpture, it originally housed 50-foot ivory-and-gilded statue of Athena,

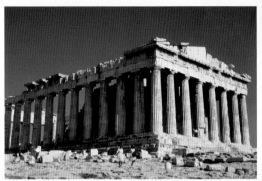

surrounded by a 520-foot marble frieze of sculpted figures.

400 BCE

421–405 Opposite the Parthenon stands Ionic Erechtheum with Porch of the Maidens—roof supported by female columnar figures called caryatids. Ionic, a later development, considered more feminine than sturdy Doric order.

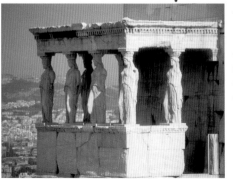

Temple of Apollo

Temple of Apollo Epicurius, begun in 420 by Ictinus, architect of Parthenon, first to use all orders: Doric, Ionic, and Corinthian. Ionic engaged columns line sanctuary leading to first known Corinthian column with acanthus-leaf capital. Temple constructed of gray limestone with marble frieze of battle between Centaurs and Amazons.

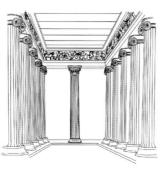

c. 200 Native Americans in Ohio River valley, termed the Hopewell culture (c. 300 B.C.E.–500 C.E.), build burial and ceremonial mounds in geometric and animal shapes, often on a monumental scale, 3–14 feet high and 1000 feet across. Site covers 4 square miles. Indigenous people use sticks and clamshells to sculpt 7 million cubic feet of dirt into probable lunar observatory. Claw of bird of prey shows skillful carving.

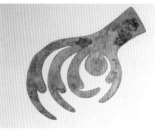

New Art in New World

Pre-Columbian art of the Americas is diverse with advanced civilizations primarily in Central America and Peru. Art takes the form of monumental stone architecture (temples, palaces, and urban complexes), stylized murals and bas-reliefs, and sophisticated achievements in ceramics, textiles, jewelry, basketry, beading, and metal-work.

300 BCE

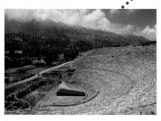

3rd Century Greek theater performed in outdoor amphitheater-like tiered semi-circle in Epirus, built into hillside for tens of thousands of spectators with marvels of acoustic engineering. Festivals and plays staged in center and front. The idea of a space designed to serve citizens rather than cater to gods or royalty marks new humanism.

3rd Century Etruscan art predates Romans; bronze sculpture highly advanced in realism and technique. Etruscans main source to spread Hellenic culture in Italy.

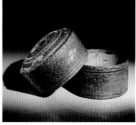

c. 200 Fluid handling of cloud scrolls, inlaid with silver, on Chinese lacquered box resembles painting, uses official conventions in formal style. Natural forms become decorative pattern, reflecting Confucian love of order, moderation.

13

Hellenistic Art

The final period of Greek art, called Hellenistic, is the most widespread, due to the vast scope of Alexander the Great's empire. A taste for ornate decoration, hyper-realism, elaborate form, and theatrical effect transforms Greek art into a virtuoso display, which greatly influences the art of Rome.

190 Hellenistic Nike of Samothrace (Winged Victory) shows striking difference from early static statues. Originally erected on pedestal-like prow of ship, drapery and wings whipped as if by wind, implying power and movement. Eight-foot-tall figure illustrates *contrapposto*, where weight no longer evenly distributed in rigid stance.

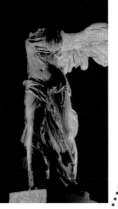

100 BCE

c. 80 Wealthy Pompeii residents embellish villa floors with mosaics in complex, colorful designs. Mosaic from House of the Faun, with Alexander the Great defeating King Darius at the battle of Issus, adopts pictorial techniques of modeling to depict plunging forms. Minute tesserae (tiles) for realistic detail (50 bits comprise 1.5-inch-wide eye).

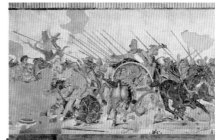

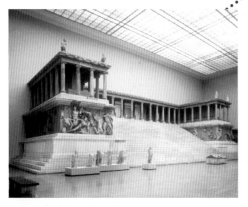

c. 156 Huge Pergamon altar atop flight of steps with two flanking peristyles and 7-foot-high frieze at base celebrates victory over barbarians. Muscular sculpted figures writhe in agony or revel in triumph. Melodrama replaces harmony and calm of Classical era.

Order in the House

The Greek system of proportion defines ideal measurements for all temple components according to mathematical ratios. The diameter of the column determines all the rest. For example, in the Doric order, a column is four to six times as tall as the diameter of its shaft and the horizontal entablature is one-fourth the height of a column. Unity, logic, and the golden mean prevail.

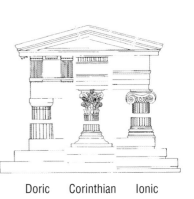

Doric Corinthian Ionic

Pompeii: Where Time Stands Still

Its history abruptly terminated by the eruption of Vesuvius in 79 C.E., Pompeii is preserved under volcanic ash, revealing the culture of Roman antiquity. A Roman colony from 80 B.C.E., Pompeii illustrates sophisticated Roman architecture: temples, a basilica, amphitheater, sumptuous public baths, and fountains. Private villas are crammed with art. Mosaics, sculpture, and frescoes reach a high level of aesthetic quality, adept in realistically representing space—an advance over the Greek emphasis on objects surrounded by undifferentiated space.

c. 50
Pompeiian villas decorated with vibrant wall frescoes like dancers from Villa of the Mysteries. "Architectural Style" of mural is visually convincing for a 3-D illusion of receding space.

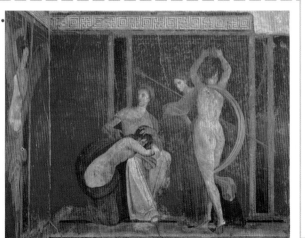

Arch v. Vault

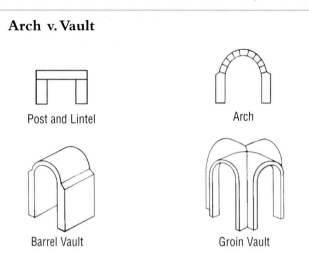

Post and Lintel

Arch

Barrel Vault

Groin Vault

ARCH. The basic building block of Roman architecture, the arch replaces the trabeated (post-and-lintel) Greek system, which depends on the column for support. Stone wedges are supported by a wood scaffold until the central keystone locks in place; then the arch supports itself and a heavy load on top.

VAULTS. A rounded arch extended in depth forms a tunnel or barrel vault, which produces an arcade to support a super-structure above. Intersecting barrel vaults at a right angle form a groin or cross-vault. Combining the arch and vault with concrete means a structure can sustain large loads. The architect can build larger and loftier. Roman innovations revolutionized architecture by allowing the enclosure of vast inner spaces.

c. 80 CE Colosseum arena inaugurated with 100 days of games including 5,000 animals. 87,000 spectators and 20,000 standing-room fans use 80 flights of stairs (called *vomitoria*). Sailors stretch huge awning atop to shield from sun. Embedded columns on exterior for decoration, not support, rise from sturdy Doric to delicate Corinthian capitals. New building form for vast public entertainment, originally faced in white and yellow travertine, has served as model for stadiums ever since. Proverb declares, so long as Colosseum stands, so will Rome. When Rome falls, so will world.

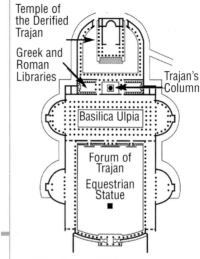

Temple of the Derified Trajan

Greek and Roman Libraries

Trajan's Column

Basilica Ulpia

Forum of Trajan

Equestrian Statue

Completed 112 Trajan's Forum shows the typically Roman concern for bilateral symmetry and imposing exteriors. The complex, designed to trumpet imperial power and prosperity, includes colonnaded courts on an impressive scale and sweeping vistas. The architect, Appollodorus of Damascus, merges the Hellenistic style of Classical ornament with distinctly Roman contributions: concrete construction and a vast interior space for human use.

50 CE

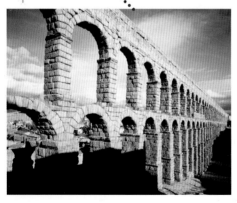

110 CE Roman aqueduct in Segovia, Spain still carries city water supply. Tiers of stone arches carry water flow from source to city by gravity with continuous gradual decline over many miles. Provides gallons of water daily for each citizen, gushing from fountains and public baths.

c. 112 Basilica Ulpia in Trajan's Forum is a gathering space, used for law, commerce, public assembly. Influential form (became model for Christian church) includes long rectangle (length twice its width) with colonnades of columns separating aisles from central nave. Semi-circular apse at end used to hear legal cases. Upper level of clerestory windows for light.

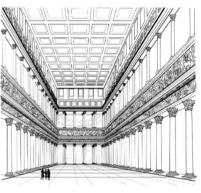

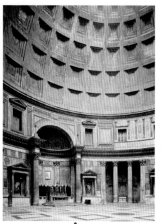

118–25 Criss-crossing arches generated in circle form a dome, as in Pantheon's 142-foot-diameter, egg-shaped dome. Diameter of dome equals height of walls of drum for perfect harmony and balance. Dome diminishes in thickness from 19'4" at base to 4'10" at central oculus, where light streams into soaring rotunda.

125–33 Emperor Hadrian builds 500-acre compound outside Rome at Tivoli. Pavilions, palaces, theaters, temples, baths unrivaled in luxury and invention. Integrates design of buildings and landscape through flowing water in canals, pools, fountains, waterfalls to enliven inanimate surfaces with sound and movement. Walls undulate like streams in alternating convex and concave curves, like rhythm of flat and arched architrave linking columns at The Canopus.

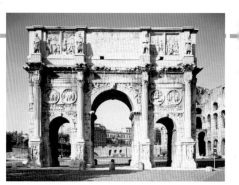

Roman Engineering and Architecture

Roman technological skill reaches its apogee in city planning and construction. Innovations like the arch, vault, dome, and concrete enable builders to span huge volumes of space, replacing the Greek architecture of weight and mass with the new Roman concept of an enclosed void. The scale of buildings becomes as vast as the scope of the Roman Empire. Roads, bridges, aqueducts, and new building types like the colosseum and basilica, amenities like indoor plumbing and heating, hot water, sewers, and public lavatories mark a high level of civilization, stamped on cities throughout the Roman world.

2nd Century Chinese bronze flying horse illustrates new realism of pose and mobility. Steeds, called "horses of heaven," prized by Han as cavalry horse in war; clay model left in tomb indicates status of deceased.

312–15 Arch of Constantine celebrates emperor's victory with two smaller arches flanking large arch, using monumental architecture to manifest Imperial might. Last great triumphal arch built before capitol of Roman Empire shifts to Constantinople, embellished with medallions and relief sculpture more medieval than Classical Greco-Roman. Composition of figure groups more frozen and emblematic, instead of individualized. Grandiosity triumphs over grace.

Plan, Pantheon, Rome

This hybrid design combines a Greek pedimented, columned porch plus a Roman dome in a widely imitated building style. Its principal innovation is the achievement of illuminated space unencumbered by vertical supports.

330 Old Basilica of St. Peter impressive in size and mass with richly decorated, 20-foot thick walls and coffered vaults.

Summarizes peak architectural achievements of ancient world with vast enclosed space covered by groin vaults, constructed of malleable, fireproof concrete, stuccoed and veneered in marble.

532–37 Hagia Sophia cathedral in Constantinople (modern Istanbul) is the pinnacle of Greek concept of order, logic, proportion combined with emotional impact of Eastern Orthodox Church. Roman elements: arch, dome, concrete, mosaics. Persian influence: central plan, vivid color, geometric designs. Oriental traits: symbolic decoration and mystic mood induced by incense, chants, hanging oil lamps. Dazzling interior encrusted with colorful pattern, irradiated by light from 40 arched windows at base of dome, 107 feet in diameter.

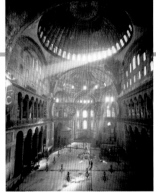

Decline and Fall

From the beginning of the Roman republic around the 5th century B.C.E. to when Emperor Constantine deserted Rome for Byzantium in 330, the Roman state is characterized by practicality, efficiency, and technical skill. Rome's major contributions to art are: realistic portrait sculpture, monumental architecture, and skillful mosaics and painting. As the Empire grows, it adopts a pumped-up, Greco-Roman style to boost Imperial rulers and inspire awe and loyalty. Hubris replaces plain Roman virtue, and art becomes more pompous, less grounded in reality, more about power. Roman culture gradually loses touch with its roots until it's cut off by the Visigoths' sack of Rome in 410.

Plan, Hagia Sophia

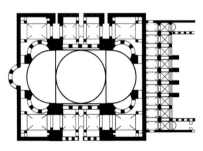

Hagia Sohpia (Holy Wisdom) by Anthemios of Tralles and Isidorus of Miletus. Four 70-foot-high piers, four gigantic arches, and 60-foot-wide pendentives support the central dome, but the effect seems weightless, as if the huge dome rests on beams of light. Half domes double the length of the nave, with peripheral galleries and aisles.

547 Empress Theodora, wife of Emperor Justinian who built Hagia Sophia, appears with her court in Ravenna mosaic. Figures are elegant, weightless, poised on tiptoe; bodies dematerialized and stiff like heraldic symbols. Byzantine art bolsters sacred and secular authority.

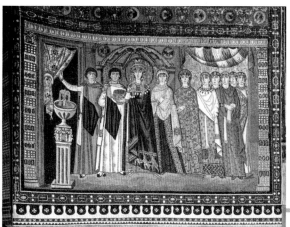

690 Ise shrine, sanctuary of Shinto goddess who founded Imperial line, built of cypress in early Japanese style of unpainted, undecorated wood with thatch roofing, adapted to local climate. Ritually rebuilt by traditional methods every 20 years; simple rustic building blends with forest setting, exemplifies style of cloaking sophistication in modesty.

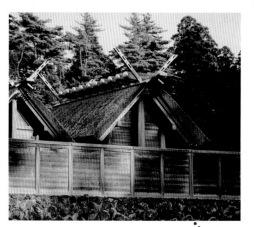

500

Byzantium Rising

After the fall of Rome in the West, Constantinople and the Byzantine Empire keep the torch of civilization burning bright during the Middle Ages. Merging Oriental and Hellenic influences, Byzantine art is no longer secular but promotes Christian theology. Opulent palaces, lavish mosaics, and soulful icons are colorful and emotionally intense.

607 Buddhist Horyu-Ji temple complex in Nara, Japan, oldest surviving wood buildings in world. Octagonal hall shows Chinese influence, with post-and-lintel construction, sloping tile roof, branching brackets to transfer weight of roof to column supports.

691 Dome of the Rock, earliest extant Muslim structure, faced with brilliant green, blue, gold tiles in abstract geometric pattern characteristic of Islamic art. Dome originally covered with gold leaf. Pointed arch introduced.

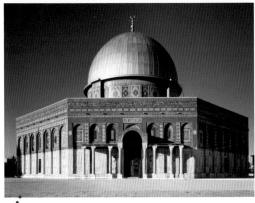

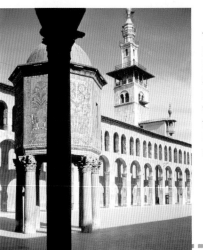

705–11 Courtyard of Great Mosque in Damascus, first Muslim building on titanic scale. Square corner towers, originally built for defense when structure was Roman sanctuary, converted to first needle-shaped minarets in Islam, signature feature of mosques.

700

Islamic Art and Architecture

Islam prohibits graven images, so sculpture is absent, and pictorial imagery is confined to textile-like geometric forms. Calligraphy is highly developed; architecture flowers with the playful treatment of arches. Ornamentation is splendid and includes flowing arabesques and interlacing abstract designs.

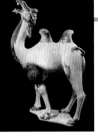

1st half 8th century Snarling camel terra cotta, part of coterie of animals and courtiers buried with high official, reveals bold color, vigorous modeling, and animated figures of China's Tang dynasty. Decorative arts turn opulent; realism borders on caricature. Model of pack animal reflects extensive trade on Silk Road.

Begun 786 Mosque at Córdova, Spain resplendent with striped, double-tiered arches. Horseshoe-shaped arches, synonymous with Islamic architecture, create billowing, airy ambience. Mosque also includes multi-lobed, scalloped arches for rich, fanciful effect.

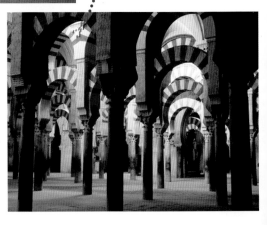

Begun 792 Architecture of Middle Ages shifts into high gear in Europe when Charlemagne adapts Roman construction techniques for palaces and churches. Palatine Chapel built with octagonal core. Weighty stone pillars and arches signal new solidity, missing in Western architecture since fall of Rome.

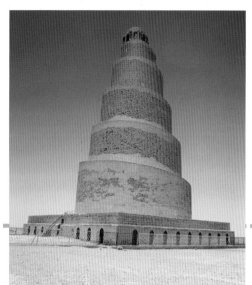

800

800 Monks working in monasteries keep civilized arts alive during Dark Ages. In Ireland, Golden Age of learning and art combine to produce illuminated manuscripts of stunning artifice. Irish and Anglo-Saxon motifs in Book of Kells mingle in intricate, ornamental style of serpentine curves.

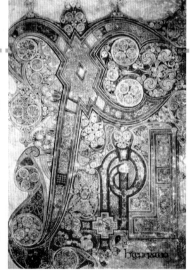

848–52 Great Mosque of Samarra, largest mosque in Islamic world, covers ten acres. Aisles surround central court with main axis facing Mecca. Single spiral minaret of fired brick, 176 feet tall, used to summon faithful to prayer.

The Middle Ages

After the downfall of the Western Roman Empire, from 400–1400, nomadic tribes form warring kingdoms in Europe. Both Christianity and the Greco-Roman heritage infuse the culture of Celtic-Germanic tribes, but in art Christian theology dominates. Liturgical objects in enamel, textiles, metalwork, ivory carving, illumination, stained-glass, sculpture, and panel painting show meticulous execution and are oriented towards the supernatural world.

Chinese Painting

Painting is the most significant art medium in China. Produced with a brush, painting must have *qi yun*, or the breath of life. Calligraphy is considered more creative, so paintings are judged on their quality of line and handling of the brush, not on composition or color as in the West. Painters learn technique through copying their predecessors, so tradition is all-important. Background details and a sense of space are gradually introduced as a linear style evolves to suggest mass and volume.

c. 1000 Toltec, successor to Maya, pyramids in the Yucatán built of solid stone with four flights of steps to temple on top. Kukulcan Pyramid at Chichen Itza 100 feet high, dedicated to god of creation. *Chacmool*, or reclining male statue, holds plate to receive hearts of human sacrifice victims. Blood deemed necessary to ensure gods' favor.

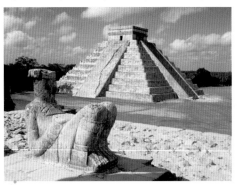

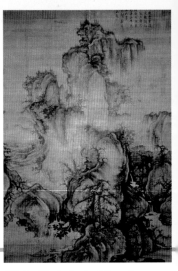

1000

c. 907 Paintings on hanging scrolls and handscrolls established in China. High level of figure painting seen in segment from "The Night Revels of Han Xizai" by court painter Gu Hongzhong. Figures shown in realistic interior setting, a new development.

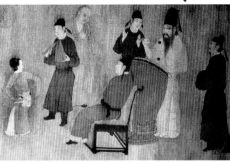

c. 1000 Ceramic teabowl of Song dynasty seemingly rough and direct but model of refined understatement. Tea cult associated with Buddhism requires cupped hands holding bowl of hot green tea. Base of bowl should feel rough, with inviting depth and texture, and smooth im. Chinese ceramics of Song dynasty integrate simple shape, soft, monochromatic glaze, and practical function in aesthetic whole.

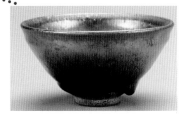

1072 "Early Spring" hanging scroll by Kuo Hsi is ink painting on silk, example of landscape from Northern Song dynasty with gnarled trees, rocky land. Praised as greatest artist of his time, the painter employs complex rhythms organized in a misty grid for an impression of depth.

22

Begun 1080 Nave of St. Sernin, largest brick structure in the world, shows rounded arch used for Romanesque cathedrals. Compound piers spring into barrel vault over nave, banded with transverse arches. Radiating chapels and ambulatory serve hordes of pilgrims vying to view holy relics. Grandeur of cathedrals, initially painted and frescoed inside, awes parishioners with sense of divine majesty.

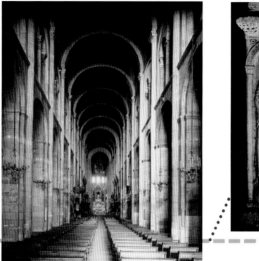

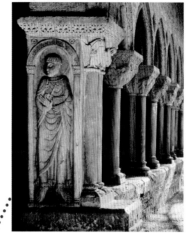

c. 1100 Statue of St. Peter adorns corner column at Moissac cloister, France. Galleries of columns with elaborately carved capitals surround central garden. Romanesque sculpture elongated to fit architectural setting, conveys intense spirituality for direct emotional impact. Figurative sculptures on churches carved in high relief, integrated with structure.

Plan, Saint-Sernin, Toulouse, France

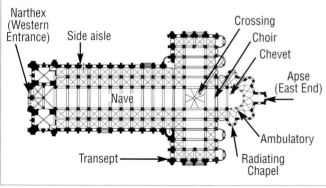

Narthex (Western Entrance)
Side aisle
Crossing
Choir
Chevet
Apse (East End)
Nave
Ambulatory
Transept
Radiating Chapel

As priests conduct mass in the nave, pilgrims circulate around the outer aisles and ambulatory chapels. Each side aisle is divided into square bays one-fourth the area of the central crossing square. A segmented interior, geometric plan, the rounded arch, and barrel vaults show the Romanesque style.

Romanesque Sculpture and Architecture

Romanesque art is primarily religious, although decorative sculpture and impressive architecture adorn fortified towns and castles. Monasteries and churches are rich with figured bas-reliefs expressing the passion of religious faith. Architecture of stone includes towers and stained glass rose windows for cathedrals. Romanesque cathedrals adopt the basilica format but add a transverse crossing wing to form the shape of the cross. The choir often displays virtuoso wood and stone carving to inspire belief and teach precepts.

c. 1150 Early Native Americans called Anasazi construct cliff dwellings with more than 200 rooms and 23 circular *kivas* for ceremonies in Mesa Verde, Colorado. Built into sandstone cliffs and augmented with sandstone blocks and adobe construction, complex epitomizes organic architecture.

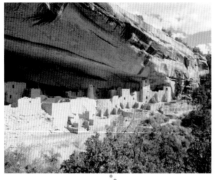

Completed 1220 Natural pose and rippling drapery evince increased realism in carved saints beside door of Gothic Chartres Cathedral. Romanesque gauntness yields to proto-Renaissance roundness, dignity.

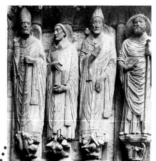

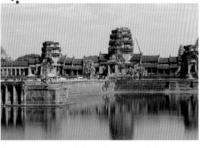

Begun 1113 In Angkor Wat, Cambodia, Hindu art flourishes. The temple complex was originally dedicated to the god Vishnu. (Since 15th century, temple has been used by Theravada Buddhists.) Extensive stone structures are covered with highly inventive, low-relief carvings, which writhe like jungle vines.

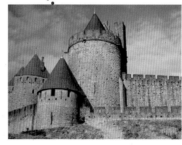

1240 Fortified village of Carcasonne, France surrounded by two concentric walls, miles of towers and battlements impregnable to invaders. Military architects design bulky stone castles with clever engineering to repel foes. Exteriors are thick with minimal openings, last gasp of Romanesque solidity.

1100

Amiens Cathedral, France

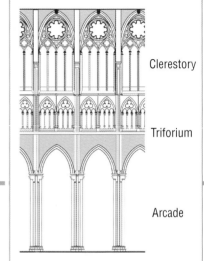

Clerestory

Triforium

Arcade

Begun 1220 Elevation and Section: The Gothic trend towards skeletal walls reaches its apogee at Amiens. Three levels of the interior are pierced with windows held by delicate tracery. Piers and colonettes are thin; the nave vault soars to 138 feet. The exterior is copiously carved with figures and furbelows, resembling petrified lace.

1240 Palace in Mali converted into Great Mosque (rebuilt in 1906), world's largest mud structure. Built with crenellated and plastered walls, tall towers studded with palm-wood posts. Towers capped with spires and ostrich eggs, symbol of fertility and purity.

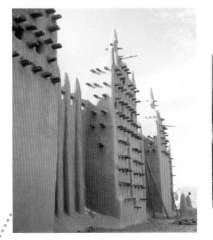

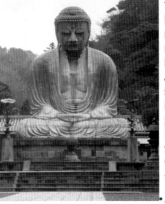

1252 Great Amida Buddha, 37 feet high, reflects idealized realism, radiates benign serenity. Japanese sculptor stylizes heroic bronze image in robust, powerful style. Proportions distorted to appear balanced when viewed from front.

Gothic Glory: the Triumph of Light

Romanesque segmented space and chunky, dark interiors yield to the unobstructed flow of light and space in Gothic cathedrals. Height and light are the goals, achieved through external flying buttresses to support the vaults and large expanses of glazing. The building's form reinforces the optimistic concept of a soul's ascent to salvation, symbolized in gravity-defying height. The pointed arch, ribbed vault, and flying buttresses are signature Gothic elements. Walls shrink from five feet thick to 16 inches.

1220

1243–48 Stained glass windows in upper chapel of Sainte-Chapelle, Paris convert wall to shell of colored glass and gilded mullions. More than 700 yards of glass, outlined by painted piers and bar tracery make walls seem to dissolve in heavenly light.

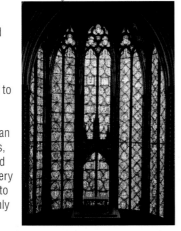

Completed 1250 Notre Dame Cathedral sets standard for Gothic style. First on colossal scale, 115-foot-high nave vault is highest yet attempted. Interior space seems all of one piece, with thin, vertical colonettes rising from floor to vault in surging upward rhythm. Weight of masonry walls is reduced through use of large expanses of glass and external buttressing as braces.

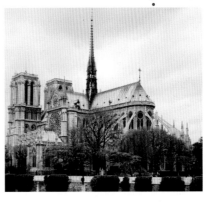

Notre Dame, Paris

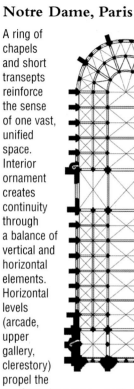

A ring of chapels and short transepts reinforce the sense of one vast, unified space. Interior ornament creates continuity through a balance of vertical and horizontal elements. Horizontal levels (arcade, upper gallery, clerestory) propel the eye from the entrance to the altar, as vertical shafts defining the apse rise in an uninterrupted sweep to the springing of the vaults.

13th century Equestrian terra-cotta figure from Djenné, Mali found in tumulus shows lively portrait sculpture. Horse with elaborate bridle represents wealth and prestige; rider's sharpened anatomy and ornament suggest high social status. No distinction in African art between fine or decorative art and craft.

Proto-Renaissance Art

Italian art of the late 13th and 14th centuries is the first to digress from Byzantine and Gothic styles. It promotes a culture based on the human body and reason instead of divine revelation. Innovations in both concept and execution lend a new dynamism and naturalism to painting and sculpture. Artists employ tonal modulations to portray bodies instead of flat areas of color and use dark and light to suggest volume. A significant shift begins, stressing life on earth instead of the after-life.

1305–6 Giotto's "The Lamentation of Christ" breaks with static medieval style, foreshadows Renaissance. More natural, less allegorical style of painting, innovative use of color, integration of figure and background result in lifelike, expressive figures. Arms of Christ appear to have weight; faces mourn, gestures express drama of scene.

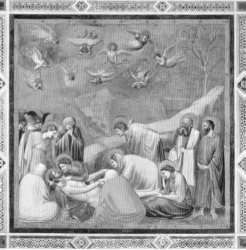

Aztec City of Tenochtitlan

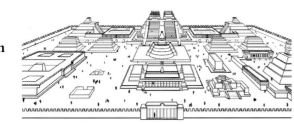

Aztec city of Tenochtitlan (beneath current Mexico City) harbors sophisticated urban civilization. Monumental pyramids modeled on earlier culture of Teotihuacan, which had more than 125,000 inhabitants until abandoned c. 600. City built as island in middle of lake with canals for transport, elaborately carved and frescoed palaces and temples, until destroyed by Spaniards in 1521.

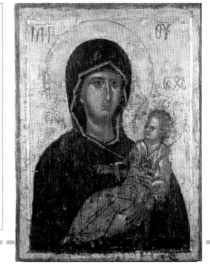

14th century Byzantine art persists in Eastern Europe: icon of Madonna and Child typical in two-dimensional, stylized portrait against gold background. Intense expression connects image of holy figure with devout worshiper.

1400

1362 Alhambra's Court of the Lions surrounded by arcades, sliced by water courses to animate space with sound and movement. Moorish palace in Granada, Spain decorated with hanging-honeycomb vault called *muqarna*. Stone-tasseled canopies, patios, multi-colored tile, carved foliage fuse interior and exterior space in wildly imaginative ensemble.

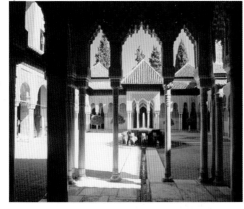

Begun 1406 Forbidden City, Beijing is huge complex of palaces, pavilions, carved stone stairways and galleries, arranged in formal symmetry. Ceremonial halls in bright red or shiny black, walled gardens, temples are contained within walls for Emperor

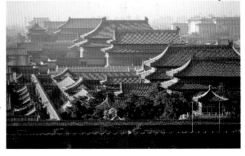

and his administration. Uniform structure and shapes in brilliant color create harmony and order. Yellow tile roofs, painted bracketing, elaborate carvings, lattice-work, and marble platforms produce vivid effect.

Renaissance to Neoclassic Art: An Age of Discovery

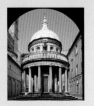

When the architect Brunelleschi saw Donatello's sculpture of the crucifixion, he was astonished, exclaiming it wasn't Christ on a cross but "a peasant on a stick." This switch from remote, stylized holy images of the Middle Ages to realistic portraits of human beings in the real world epitomizes the Renaissance.

The fifteenth century was an age of discovery, with explorers sailing the seas to discover new lands, scientists proposing theories that contradicted dogma, and reformers urging new forms of worship. In art, new discoveries gave a fresh way to picture the world. Brunelleschi discovered the principles of perspective, allowing realistic views of receding space, and the study of anatomy permitted convincing renditions of the human body.

It was also an age of rediscovery, as artists and writers in Florence, Italy spurred a revival of interest in the art, architecture, and literature of ancient Greeks and Romans. The church was no longer supreme arbiter of all things. Man became the central focus in this new humanism borrowed from antiquity. Instead of depending on divine revelation for knowledge, reason became the touchstone. After the fall of Constantinople in 1453, educated Greeks fled to Italy, bringing more knowledge of the Greco-Roman world.

As mercantile capitalism replaced feudalism, the Medici family in Florence rose to great prosperity, lavishly spending their wealth as patrons of art and architecture. Artists like Leonardo and Michelangelo (who was called "Il Divino," or the Divine One) transcended the former view of painters, sculptors, and architects as anonymous craftsmen. Artists were now considered poets, philosophers, and universal geniuses. Personal styles emerged, and artists were virtually worshipped, culminating in the High Renaissance of 1500–1520, when the work of Leonardo, Michelangelo, Raphael, and Titian attained near perfection.

After Columbus discovered America in 1492 and Magellan circled the globe in 1519–22, the "flat earth" theory was no more. Artists had already jettisoned flat portrayals for rounded figures, with harmonious proportions based on Classical ideals and balanced, unified compositions. Gradually these innovations spread from Italy to Northern Europe, where they were taken up with enthusiasm. When German theologian Martin Luther nailed his 95 Theses to the church door in 1517 calling for religious reform (later seconded by Calvin) and Henry VIII established the Church of England, it spelled the end of Church dominance and kicked off the Reformation. Art became increasingly secular, with new genres like still life and landscape, as well as a focus on portraits and self-portraits.

Printing was invented in China as early as the 6th century and arrived in Europe around 1440 when books with woodcuts began to be widely disseminated. By 1500, nine million books were printed, spreading the ideas and techniques of Renaissance Italy throughout Europe. Wealth pouring in from New World colonies supported artists, whose work was in high demand.

After the accurate portrayal of the world and the human figure—in all its nobility and individuality—was achieved in the Renaissance,

the next generation of artists sought its own imprint. Their work tilted the harmony and order of the High Renaissance askew, in an exaggerated, mannered style known as Mannerism. This view of the world added drama and emotion—even personal, eccentric visions—to the Renaissance mastery of technique.

By the end of the sixteenth century, Europe was in upheaval. Religious wars raged during the Reformation and Counter-Reformation, and national states like France, Germany, and England consolidated into wealthy countries. As kings eagerly spent fortunes on their palaces and the revitalized Catholic church reclaimed its influence, Baroque art surged onto the scene. The seventeenth century was an optimistic, exuberant era. Its art embodies high energy, intensity, and force, as well as bombastic excess and pomp.

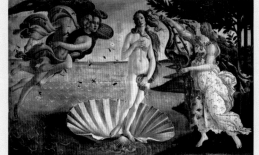

Baroque art reigned wherever kings enjoyed unlimited power: in France, Germany, Austria, England, and Spain. In Italy, the Pope was a generous patron who encouraged artists to produce works of towering visual splendor.

In the sciences, with intellects like Galileo, Kepler, Harvey, and Newton, it was a "century of genius." Newton's laws of motion revolutionized rational thought, and in art and architecture, fluidity and dynamism characterized Baroque forms.

By the eighteenth century, after the death of Louis XIV in 1715, tastes shifted once again, away from the rigid formality of Versailles to a light-hearted style. Voltaire's mistress summed it up: "We have nothing else to do in the world but seek pleasant sensations and feelings." Baroque grandeur gave way to the sparkling gaiety of Rococo art, as the pace picked up from a stately canter to a giddy gallop.

By 1750, a reaction arose against Rococo's sugary scenes of frolic, and an austere Neoclassic style came to the fore. The French painter David drew modern moral lessons using Classical themes. His mythological scenes embody righteousness and steady equilibrium. In England, Hogarth ridiculed high society, Chardin painted down-to-earth tableaux in France, and the Spanish iconoclast Goya railed against the hypocrisy and decadence of human behavior, painting distorted monsters "to perpetuate," he said, "the solid testimony of truth."

As the Industrial Revolution began to change the sources of energy, labor, transportation, and manufacturing in England in the late 18th century, threatening the stability of the world as people understood it, nostalgia for the past ran rampant. Romanticism reared its head, as Neo-Gothic architecture demonstrated a yearning to escape into a fantasy world of feelings and imagination.

By the late 18th century, this revolutionary epoch in the arts saw political revolution as well. Encouraged by Enlightenment concepts of human dignity and equality, both the American and French Revolutions overthrew monarchies to establish the Rights of Man.

The 400 years from 1400–1800 were a time of continuous change, with an accelerating pace of stylistic turnover in the arts. One quintessential Renaissance man, Francis Bacon, noted that age is "best in four things—old wood best to burn, old wine to drink, old friends to trust, and old authors to read." During the era that followed the Middle Ages, artists turned to the old masters of antiquity for inspiration, but they fashioned new attitudes and new forms that reached a height for all time.

c. 1415 Brunelleschi develops system of linear perspective (based on scientific method and geometry) that revolutionizes painting, characterizes Renaissance art. His rational principles create the illusion of receding distance in painting. Architect uses effects of perspective in nave of San Lorenzo to increase sense of magnitude and unity.

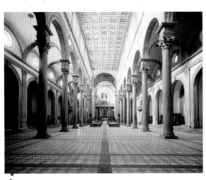

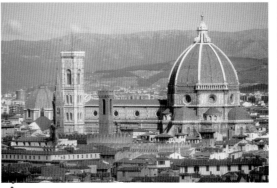

Begun 1420 No one in Florence has remotest idea how to cap central octagon of Gothic Florence Cathedral until Brunelleschi, founder of Renaissance architecture, proposes thin, double shell for 138-foot-diameter, ribbed dome. Brunelleschi applies ingenious methods in unified design of rectangles and circles. Heavy lantern at top stabilizes whole.

1400

c. 1416 Three Limbourg Brothers produce masterpiece of manuscript illumination for French patron Duke of Berry. *Les Très Riches Heures*, or Very Rich Book of Hours, portrays calendar scenes in refined detail, holdover from elegance, artificiality of International Gothic Style.

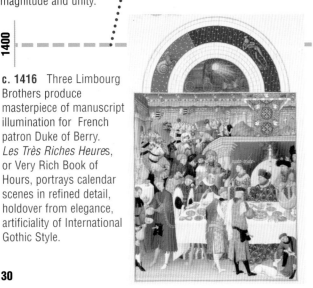

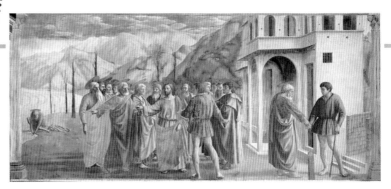

c. 1425 Pioneer of new optical style, Masaccio is one of first to use central perspective for sense of depth. He creates realistic sacred scenes like "The Tribute Money" fresco. Note shadows indicating light from single source, technique borrowed from antiquity. Roundness of forms replaces expressionistic distortions of Gothic style.

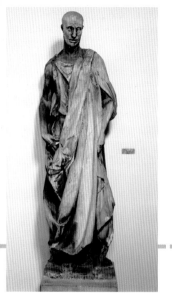

c. 1434 Greatest sculptor of 15th century, Donatello sculpts "Prophet" (dubbed *Lo Zuccone*, or Squash-head), clad in Roman toga, for Florence Cathedral. Shows Renaissance stress on anatomy and Classical proportion. Innovations: increased realism (ugly yet noble), emotional intensity, psychological insight. So lifelike is statue, Donatello shouts while creating it: "Speak, speak, or the plague take you!"

1434 Flemish painter Jan van Eyck depicts scenes of bourgeois life, using new oil medium to capture precise detail as minutely as book illuminator. In "Arnolfini Wedding," he achieves peak mastery in double portrait's glowing effects of color, illusion of texture and reality. Highlight of Northern Renaissance.

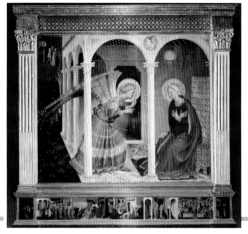

c. 1434 Transitional figure, Fra Angelico—both monk and painter—unites Gothic concept of art as manifestation of religion with Renaissance humanism and innovative execution. Figures simplified but with tangible corporeality; space implied through light and color with luminous atmosphere. In "Annunciation," both archangel and Virgin Mary framed under arch to inspire reverence. Balanced composition, naturalistic bodies and drapery combined with delicacy, piety.

Breakthroughs in Renaissance Painting

The discovery of perspective, using a central vanishing point to suggest depth and draw in the viewer, initiates a more representational style, a major turning point in European art. New emphasis: instead of art as a symbol of the divine, the keynote is imitation of nature. In the 1400s, this approach spreads from Florence to Rome, then Venice. In the next century, Northern Europe adopts the ideals and techniques pioneered in Italy.

1434–35 Brunelleschi models Santo Spirito on the Roman basilica, with mathematically-related units. The square under the crossing is the basic module, repeated in the choir, transept arms, and four squares of the nave. Quarter-squares defined by Corinthian columns form aisles.
A linear grid underpins the simple, rational composition, inspired by a study of Roman ruins.

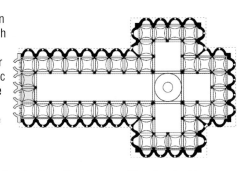

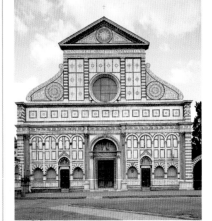

Begun 1456 For Alberti, geometry plus classical ornament equals beauty. Florence's Santa Maria Novella is all squares and circles with its upper level-like pedimented temple; lower level re-interprets triumphal arch. Whole façade fits inside square of equal height and width, with two squares of lower level one-quarter size of whole. Adds strong sculptural force of ancient Rome to Brunelleschi's delicate lines.

Renaissance Architecture

Harking back to the balance and harmony of Greek and Roman classical architecture, architects in the Renaissance install proportion and a geometry of flat, straight lines as guiding principles. From 1420–1600, structures of clarity, stability, and poise are cloaked in the ancient Roman forms of column, capital, arch, and dome.

c. 1460 Incan city of Machu Picchu built on ridge in Andes Mountains at altitude of about 8000 feet.

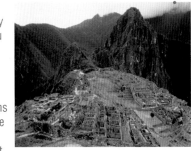

Elaborate complex of about 200 structures constructed of dressed blocks of granite without mortar. Nestled into craggy landscape, many components hewn out of rock base.

c. 1482 Japanese painter Soami designs garden surrounding Temple of the Silver Pavilion in Kyoto as if composing landscape painting. Trees arranged for "natural" effect to

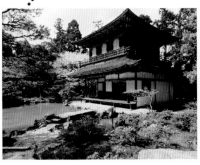

display seasonal foliage changes; pond's artificial islands appear uncalculated. Humble, post-and-lintel structure of natural wood is pavilion for Zen tea ceremony.

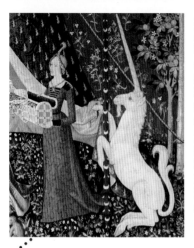

c. 1484 Style of Late Middle Ages persists in Unicorn Tapestries, probably of Flemish origin, woven of silk and gold thread in Netherlands. Considered art form of kings because so sumptuous and expensive to produce, costly weaving is as detailed as manuscript illumination, depicts hunt for mythical unicorn, symbolically linked to Passion of Christ and fertility.

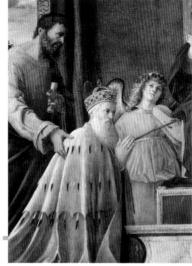

1488 Giovanni Bellini's Barbarigo Altarpiece, commissioned by Doge Agostino Barbarigo (the highest official in Venice at the time, he is portrayed as both majestic and human), demonstrates skilled draftsmanship through crisp lines, sumptuous color, sharply defined shapes. Adopts oil paint for deep, rich color without harsh shadows. Bellini is father of Venetian style, which highlights physicality and sensuality of body. Pioneers intimate, secular treatment of religious subjects.

c. 1486
Botticelli espouses neo-Platonic philosophy in allegorical "The Birth of Venus." (Neo-Platonists hold that soul glimpses God through contemplation of beauty.) Sinuous lines and curves; decorative, stylized objects and figures

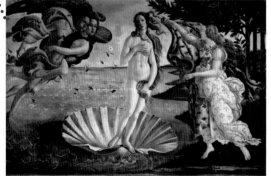

show originality in creating impression of movement through rippling drapery and windswept hair. Shows revival of interest in mythology.

Before 1492 Hopi kachina spirit embodied in carved "doll," representation of masked human figure impersonating supernatural being. Kachina cult in southwest U.S. since 1325 celebrates spirits who live in hills, assist with agriculture. Objects used in ceremonial rituals carved from cottonwood root, seasoned with clay, painted with earth pigments.

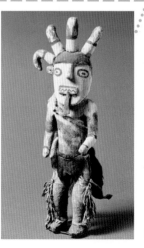

33

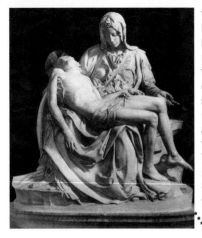

1498–99 Michelangelo's Pietà, begun when he's 23, illustrates belief that God's purpose revealed in beauty of human form, since art is instrument of divine will, and artist earns salvation through creative process. Bones, musculature anatomically accurate, drapery folds billow, skin seems soft. Youthful Virgin represents immortal church. New image of human being: heroic in form with ideal proportions.

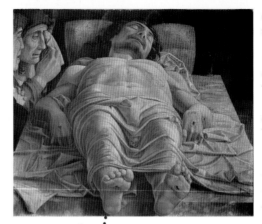

c. 1501 Mantegna scandalizes society with ultra-realistic portrayal of "The Dead Christ." "Worm's eye" point of view derived from mathematical rules for reducing measurements according to perspective formula. Viewpoint at feet of Christ unprecedented. Foreshortened body and central vanishing point draw viewer into picture. Anatomy of body is precise, has sculptural effect, powerful impact.

1500

Renaissance vs. Medieval Sculpture

Medieval art is didactic and narrative, spelling out the tenets of Christian belief. Its sculpture, decorating portals and facades, is an integral part of the structure of buildings. The Romanesque style renews monumental sculpture, which was absent during the Byzantine era, with densely crowded compositions, carved in relief, of writhing, entangled figures—saints, sinners, fantastic and demonic creatures. Gothic statues are still designed for an architectural framework but are more symmetrical and clarified. Gothic carving is deeper, the statues more realistic and rounded with great emotional impact. Renaissance sculpture reflects a new attitude towards the human body; nudes reappear (the first since classical antiquity). Even statues in church niches are more stand-alone, carved in the round, freed from masonry. Figures (simultaneously naturalistic and idealized) are balanced, with body parts articulated to appear mobile.

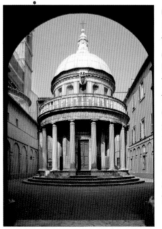

c. 1502 Bramante's Tempietto ("little temple") echoes classical temples with Doric peristyle, epitomizes High Renaissance. Modeled on Temple of Vesta at Tivoli, small-scale monument to St. Peter is constructed in concentric circles with strict symmetry and simplicity. Mathematical ratios produce harmony: height to base of dome equals width. Bramante adds personal style to antique template.

Leonardo, Renaissance Man

Not content to be a sublime painter, Leonardo da Vinci is also a gifted sculptor, mathematician, architect, engineer, inventor, and musician. A connoisseur of literature and philosophy, this omni-competent genius is the most extreme example of a Renaissance humanist. He considers painting a science, so his studies of geography, the physics of light, and anatomy allow lifelike likenesses, infused with psychological nuance. Leonardo also designs an armored tank, a magnetic compass, a submarine, a repeating crossbow, and flying contraptions. Infinitely curious, when hired to paint an altarpiece, he first studies tides in the Adriatic, then recommends measures to prevent landslides before painting the background. This archetypal philosopher-scientist says only two things are worth painting: "man and the intention of his soul."

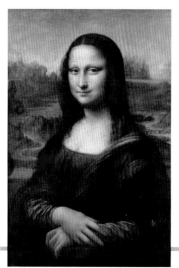

1503–6 Leonardo's "Mona Lisa" uses atmospheric perspective (progressively reducing sharpness of definition as distance increases) to create sense of depth. In most famous portrait, Leonardo pioneers technique of *sfumato*, building form from thin layers of glaze "like smoke," exemplifies *chiaroscuro* (contrasting light and dark). Enigmatic smile lends psychological dimension. Leonardo convinced painting is *cosa mentale*, not merely pretty but a thing of the mind, translating the human condition into a visual object.

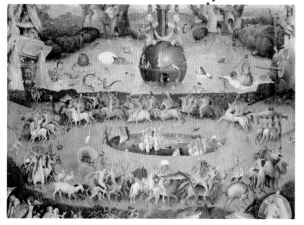

c. 1504 Bosch's invention evident in surreal fantasies of "The Garden of Earthly Delights." Symbolism refers to beginning and end of world; detail from central panel displays dissipated life on earth, riot of hedonism and lust. Dutch painter is orthodox Catholic with bizarre imagination, creates grotesque hybrid creatures to terrify sinners to repent.

1507 Raphael, at age 24, paints "Madonna of the Finch," with balanced, pyramidal composition centered on idealized image of Virgin Mary. Works are ultimate in harmony, formal simplicity, brilliant light and color, epitome of High Renaissance. Holy figures of Mary, Jesus, and John the Baptist are healthy human beings who radiate inner serenity. Known for portraits and Madonnas with rich color, subtle characterization.

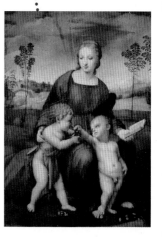

1508–12 Michelangelo paints "The Creation of Adam" fresco for ceiling of The Sistine Chapel, ultimate expression of heroic nude, exalted to level of sublime. Light from left models perfectly proportioned figure with subtle shadows. Adam's foreshortened right arm and twisted torso express drama of barely arrested movement. Arm extended towards God implies yearning for the divine. Michelangelo protests to Pope he's sculptor, not painter. Gives painted images unsurpassed sense of sculptural volume.

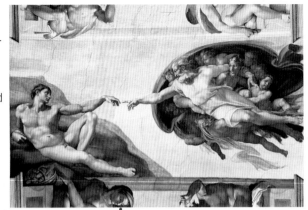

The Northern Renaissance

Dürer and Holbein import Italian Renaissance ideals into Germany around 1500, while Brueghel applies its ideas in the Netherlands. The new Renaissance outlook, fused with native roots, produces a new style, replacing spiky forms with softer, rounded flesh. The range of color, draftsmanship, and light effects reach an apex of mastery as the Renaissance spirit of freedom and individualism liberates artists from narrow Gothic conventions. Artists exploit the oil medium for maximum realism.

1510

c. 1505–10 Giorgione's "The Tempest" heightens importance of landscape with dramatic storm clouds and murky atmosphere. Integrates human figure into nature as equally important, turning point in Venetian art. Uses highlights and shadows, ambiguous imagery in lyrical pastoral scenes inflected with mystery. First to make connotation rather than subject matter dominant; artist's imagination creates "landscape of mood."

c. 1510–15 Correggio introduces asymmetric rhythm, sharper contrasts in "The Mystic Marriage of St. Catherine," foreshadowing Mannerism. Known for

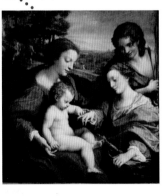

soft, voluptuous nudes, *chiaroscuro*, sensitive landscape backgrounds, he applies *sfumato* technique.

1513 Humble Administrator's Garden in Suzhou, China frames views and distant vistas across ponds, accented by

bridges, pavilions, carefully pruned trees and harmonious plantings. Chinese garden designed as series of experiences with oddly shaped trees and rocks, flowers arranged as if in still life, geometric borders, pavements, and railings—all to enhance contemplation.

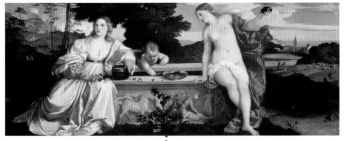

1515 Allegorical subject of Titian's *"Amor Sacro e Amor Profano"* (Sacred and Profane Love) gives him leave to portray sensual, erotic nude under guise of mythology. Nude at right poses seductively, contrasted to clothed figure of sacred love, but both are luminous, sumptuous. Greatest painter of Venetian school, Titian combines lyricism and worldliness, his subjects rendered in bold, vivid colors.

1526–28 Pontormo exemplifies full-blown Mannerism, successor to High Renaissance style, in "Descent from the Cross." Composition is a jumble of agitated figures around a central void, bursting with turbulent movement. Acidic colors, poignant expressions create emotional tension, mirror Pontormo's neurotic temperament.

Printmaking

Dürer raises the art of the woodcut to a virtuoso level, drawing his designs in black on a white block. All except the black lines is cut away, leaving the lines in relief. His innovation: instead of outlining contours only, he uses lines for subtle shading to approximate texture and light-dark tones. Dürer is also a master of the new copper engraving technique, in which lines are incised. He uses cross-hatching, parallel hatching, and stippling to convey sculptural form, which elevates prints to the refined level of painting.

c. 1515 German painter Matthias Grünewald produces masterpiece, Isenheim Altarpiece. Side panel shows "Resurrection" in which Christ displays wounds from nails and lance, transfigured into incandescent beauty. Expressive color and distortion convey emotional intensity, triumph over suffering and death. Spirit of painting is medieval. (Grünewald focuses on religious subjects, especially crucifixion.) Technique is Renaissance.

1527 Painter and engraver Dürer introduces to Germany new concept of artist as humanist scholar, applies rational Renaissance ideals to fine art. Cultivates learning to encompass array of skills, is foremost printmaker of era. His woodcuts and engravings widely circulated and influential. drawing "The Open Book" shows precise, linear draftsmanship of graphic work. Introduces genre of self-portrait, in keeping with glorification of artist.

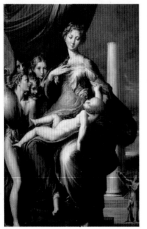

c. 1535 Mannerist painter Parmigianino displays originality in "Madonna with the Long Neck," distorting form for unusual effect. Elongated figures and chilly palette evoke disturbing mood, perhaps reflecting his melancholy, eccentric personality.

c. 1538–40 Late Mannerist style of Bronzino's "Portrait of Cosimo I de Medici as Orpheus" portrays aristocratic patron as mythological musician. Strong, sinuous contours, smooth surface, delicacy and elegance considered sophisticated. Cool, insolent expression, haughty formality of pose declare rank and culture of wealthy subject, Grand Duke of Tuscany.

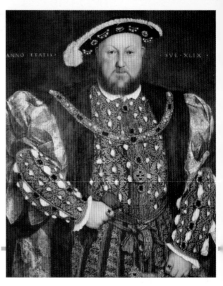

c. 1537 Michelangelo designs piazza and surrounding buildings, Campidoglio (Capitoline Hill) in Rome, invents Mannerist twist

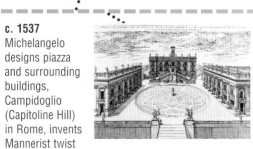

on classical motifs. Sculpts entire public square as plastic composition of intersecting solids and voids, unified by oval in center. Novel use of giant order with pilasters extending over two storeys exemplifies revolutionary approach to Classical ornament— not just appliqué or decorative but dynamic, organic.

1540–3 Cellini, sculptor and goldsmith, creates salt-cellar of gold and enamel for French King Francis I, most famous

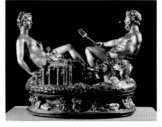

Renaissance relic. (King lures him with promise: "I will choke you with gold.") Bravura metalwork arranges meticulously detailed mythological figures in cantilevered curves. Neptune and female Ceres personify Sea and Earth. Neptune presides over boat containing salt; Earth has miniature triumphal arch with pepper.

1540 Hans Holbein the Younger, who excels at realistic portraits, brings Renaissance ideals to English court of Henry VIII. King's proud stare, swaggering pose, rich garments project attitude of power, pomp, magnificence. Holbein, through extraordinary draftsmanship, captures personality and psychology of subjects, as well as minutely detailing external world.

1555–61 Byzantine influence persists in Russia long after fall of Constantinople in 1453. Cathedral of St. Basil the Blessed in Moscow retains colorful cladding of Byzantine style. Patterned onion dome is adaptation to northern climate, since sheds snow more than shallow dome. Traditional cross-in-square plan with multicolor tiled surface.

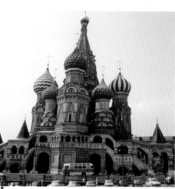

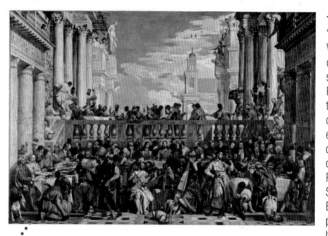

1562–3 Grandiose "Wedding at Cana" by Veronese is example of his specialty—festive scenes. Good friend of Palladio, Veronese typically incorporates classical architectural elements as framing device. This painting done for refectory by Palladio on island of San Giorgio Maggiore. Blazing color, pomp and pageantry, epic size are his signature traits.

1560

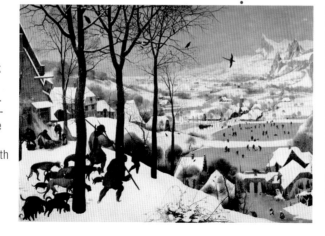

1565 Flemish painter Pieter Brueghel the Elder highlights life of peasants in "Return of the Hunters," innovative work that appeals to middle-class public instead of rich patrons. Blends figure with nature, distant view of town in new style of painting (genre scene of everyday activities merged with landscape). Clarity of detail from foreground to distant background evident.

Cellini, Consummate Courtier

Benvenuto Cellini is a passionate Renaissance man, par excellence, who advertises his virtuosity in a racy auto-biography. This rollicking book tells all about his feats in love, war, art, and court intrigue. A mini-Michelangelo, he's banished from Florence after brawling, later kills a man, is imprisoned in Rome for theft of jewels, but he still manages to brag about his colorful adventures with the total aplomb of an egotistical *artiste*. Cellini represents the artist as self-proclaimed genius, liberated from conventional strictures of society.

1566–71
Inspired by the Pantheon, Palladio designs Villa Rotonda as epitome of symmetry; his structures widely copied in America and Europe for centuries. Country villa extends around

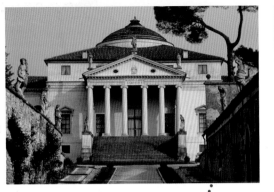

central axis with four portico fronts, four flights of stairs, central domed rotunda. Avid follower of Roman models, Palladio enshrines proportion, clarity above all.

Villa Rotonda

Bilateral symmetry shows geometric basis of design. Each room conceived in proportion to next for total unity, harmony. Captures splendor of antiquity with Palladian touch of airy elegance.

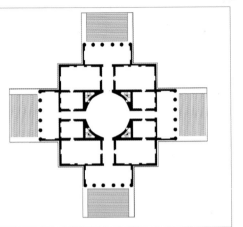

1583 Greatest Mannerist sculptor, Giambologna entwines three marble figures in twisting spiral in "Rape of the Sabine Woman." Anti-classical style piles torsos in straining, hysterical column, antithesis of Renaissance ideal of balance, symmetry.

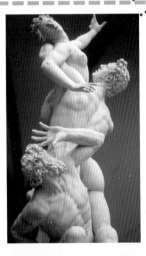

1594 Tintoretto pioneers anti-classical Mannerist style in Venice. "The Last Supper" composed as diagonal slash (instead of figures parallel to picture plane) with starkly contrasting darks and lightsand rough brushwork for melodramatic effect. Usesexaggeration, off-balance sense of upheaval for impact aimed at senses more than reason. His motto: "the drawing of Michelangelo and the color of Titian."

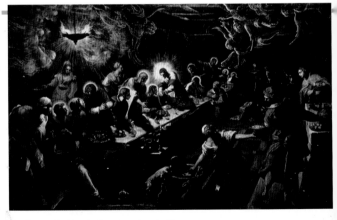

Mannerism

Mannerism is a style (or *maniera*) that bristles with tension and energy, replacing the static calm of the High Renaissance with crowded, tumbling compositions. Its main traits are artificiality, exaggeration, distortion and contortion of figures, strained poses, vivid lighting, and lurid color. Often compositions are off-kilter or diagonal, without focal point, crowded with frenzied figures. This heightened sense of drama produces a powerful emotional effect on the viewer.

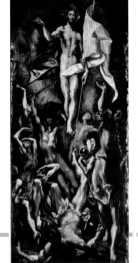

c. 1596–1600 El Greco's "Resurrection of Christ" shows extreme elongation of Mannerism. Strident colors, violent poses, agitated bodies contrasted to serene expression of risen Christ. Composition reinforces idea of resurrection, as Christ floats above anguished world, in nimbus of divine light.

1609–16 Six slim minarets accentuate corners of Istanbul's Blue Mosque, composition of cascading domes and semi-domes based on Hagia Sophia. Monumental entryway and classical courtyard bordered by columned peristyle form portico covered by 30 small domes. Interior dome rests on four pointed arches, four smooth pendentives, supported by four colossal columns; 260 windows flood interior with light. Highlight: colored tiles on lower walls with elaborate floral and tree patterns.

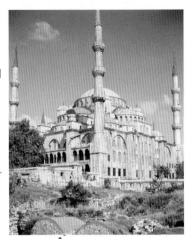

1600

c. 1601 Caravaggio's "Conversion of St. Paul" dramatizes moment when apostle is startled by voice from heaven, toppling him from horse. Extreme realism of figures combined with foreshortening and theatrical spotlight create sensational impact. Most original painter of 17th century, Caravaggio invents techniques that herald Baroque era, completely revamps religious imagery, producing canvases fraught with human, you-are-there emotion.

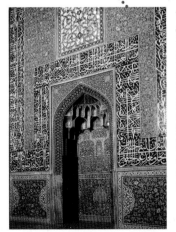

1603–19 Stylized geometric designs of mosaic tile decorate Mihrab (prayer niche) in Iranian mosque in Isfahan. Arabesque patterns of Islamic architecture resemble flowing calligraphy. Rich decoration and floral opulence of intertwined motifs reminiscent of intricate Persian carpet.

41

The Tenebrists, or Caravaggisti

Tenebroso means "darkly obscure," a trait of paintings by Caravaggio and his followers. This dramatic use of chiaroscuro influences Italian, French, Dutch, and Spanish painters in the 17th century and injects new life into painting, which had become attenuated and effete during the Mannerist fad. The perspective in these dimly lit "night pictures" and a secular, non-idealizing approach draw the viewer into the scene for an intense experience, hyper-real and immediate.

1616 Frans Hals, known for smiling portraits, captures entire militia company in "Banquet of the Officers of the Civic Guard of St. George." Vivacious Dutch officers shown in scene of indulgence and bourgeois well-being. Flag carried by standard-bearer parallels diagonal line of table, which unifies individualized portraits, lending air of spontaneous movement. Hals is known for loose brushstrokes, joyful atmosphere, fleeting expressions.

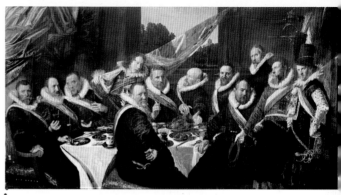

1612 Rubens' "Descent from the Cross" is quintessentially Baroque with its lush color, robust vitality, monumental grandeur. Theatrical lighting, sensuous bodies, and sinuous curves leading eye to central figure characterize this Flemish painter's work. Surging brushstrokes contribute to sense of movement.

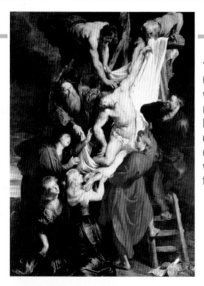

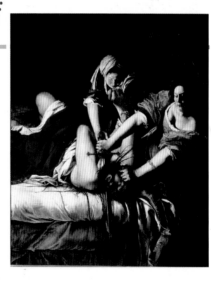

c. 1620 One of first women to gain recognition as artist, Artemisia Gentileschi specializes in images of women wreaking vengeance on men, as in Biblical scene "Judith Slaying Holofernes." A follower of Caravaggio, she uses elaborate compositions with stark lighting for dramatic effect and takes a proto-feminist stance, championing strong heroines.

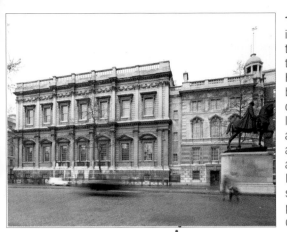

1623 Inigo Jones introduces his interpretation of Palladian style to England. Banqueting House has rusticated base like Italian palazzo, classical swag at capital level, balustraded roof, and lower windows with alternating triangular and rounded pediments. Interior is one large space—a harmoniously proportioned double cube 110 x 55 x 55 feet.

1630–53 India's Taj Mahal blends architectural composition and setting, with acres of gardens, procession of dark cypresses, and reflecting pool leading eye to marble mausoleum. Four minaret towers frame central domed building. Built as memorial to shah's wife, structure seems to float, through interplay of voids and lacey walls that appear translucent.

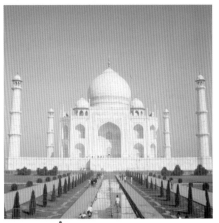

Baroque Era: All the World's a Stage

Baroque art (1600–1750) substitutes passion and dynamism for the rationality and stability of the Renaissance. Symmetry flies out the window, replaced by figures irregularly arranged, often on a diagonal axis. Grandiose theatricality trumps understatement, as Baroque art pitches to the emotions, not the mind. Painting and sculpture come to the aid of the church during the Counter-Reformation, with unsurpassed splendor and grand scale. Hallmark of Baroque: mastery of light effects for maximum emotional punch.

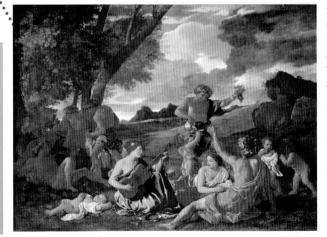

1627–8 Poussin's "Le Grand Bacchanal" typifies his Neoclassical ardor for ancient mythology with its toga-clad figures, nymphs, and *putti* (cherubic cupids). Landscape is more than background, provides bucolic atmosphere for idealized, sensual figures reveling in arcadian delight. Cool perfection of technique tinged with hint of melancholy.

1631 Willem Heda's "Breakfast Table with Blackberry Pie" is example of vogue for still lifes in affluent Netherlands, where middle-class demand for paintings is high. Heda's specialty is "breakfast piece" paintings, highly detailed with enamel-like finish. Typically on his menu: ham, oysters, mincemeat pie. The still life genre is considered inferior elsewhere, but in Holland it reaches a peak of exactitude as artists explore light reflecting off surfaces.

c. 1630s Zurbarán is Spanish master of still life as well as portraits of solitary monks. In tableau of crusts of bread, he uses a typically dark background for direct presentation, with striking contrasts of white and brown. Hyper-realistic objects are defined by light and shadow, composition seemingly unstudied but balanced. Combines power with simplicity.

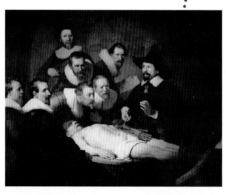

1635 Van Dyck's jaunty portrait of King Charles I of England engaged in a hunt sensitively combines frothy landscape and slickly executed royal figure, posed to dominate composition. King's face accentuated by framing halo of black hat; repeated beige colors unify elements into refined, elegant whole.

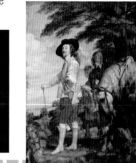

1632 Rembrandt immortalizes mortality in scene highlighting dissection of corpse's arm in "Anatomy Lesson of Dr. Tulp." Most famous Dutch painter's work is realistic (contrasted to idealized images in Italy), accurately transcribing visible world. Great master of light and shadow uses chiaroscuro to delineate personality, texture, surface effects. Dramatic gestures, vivid expressions, polished finish raise Baroque style to pinnacle.

Borromini, Mad Genius: The Agony and the Insanity

This architect who invented High Baroque style is both supremely inventive and colossally eccentric—if not neurotic—always stretching the Renaissance rules to make them dance. Borromini's life, like his designs, is unorthodox. Moody, fanatically perfectionist, he concentrates obsessively on minute details. Considering his buildings his babies, when a workman makes a mess of stonework, Borromini has the man beaten so severely, he dies. Borromini's total devotion to art flares into morbid paranoia. He wears only black and terrifies others, roaring like a lion and grimacing as if possessed. Finally, he throws himself on his sword and bleeds to death as he stoically dictates his will and obituary.

1638–41 Most inventive Baroque architect Borromini shows genius in dome of Rome's San Carlo alle Quattro Fontane. Revolutionary design uses oval plan, honeycomb dome, with dynamic rhythm of alternating convex and concave walls. Blends architecture and sculpture, molds space as if plastic. Church officials praise this building for "caprice, excellence, and singularity."

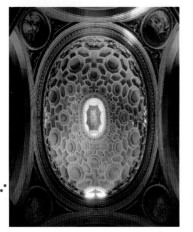

Plan, Sant'Ivo alla Sapienza, Rome

Borromini transforms the regular Renaissance rhythm of a rounded dome into syncopated multi-faceted lobes through his intricate geometry and fluid handling of space. The cornice swoops and undulates, carving out solids and voids. Atop this novel form, Borromini places a lantern shaped like a spiraling ziggurat.

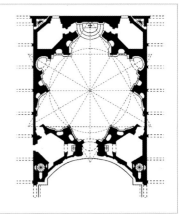

1645 French painter La Tour demonstrates mastery of chiaroscuro in "The Newborn Child." Most gifted of Caravaggio's followers, he specializes in night scenes lit by candle to cast glow over subject. Forms simplified for impression of monumental serenity. Light sucks viewer into intimate circle of stillness.

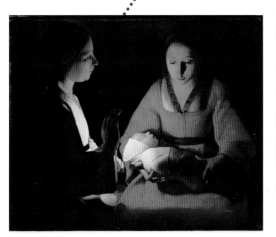

Building Baroque

Renaissance architecture, with its passive appeal to logic, geometry, symmetry, and simplicity, yields to the hyped-up activism of Baroque drama. Special effects of lighting; extravagant, multimedia materials; and billowing, undulating curves create architecture with impact. Baroque retains Classical motifs like columns, domes, and arches but revs them up, twists them, and breaks them into swooping forms that seem to move. Vast scale, rich materials, contrasting colors, control of light, and rich ornament serve as visual analogues of the power of church and state.

1645–52 Bernini's "Ecstasy of St. Theresa" is quintessential Baroque sculpture, fusing painting, architecture, and sculpture in total environment to over-whelm senses. Marble statue shows saint swooning on cloud as angel aims divine dart and golden beams of light fall from painted vault of heaven. Goal: to induce intense religious passion.

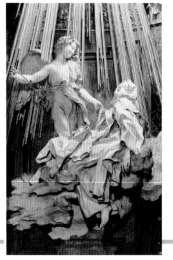

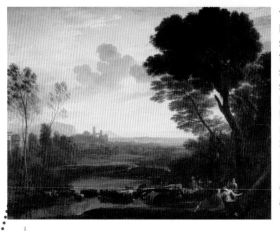

1648 Claude Lorrain inaugurates landscape painting in France, subordinating classical figures to misty mood of Italian country-side. Figures included to give sense of scale and perspective but primary love is distant horizon, panoramic setting rendered in minute detail. Scene titled "Landscape with Paris and Oenone" or "The Ford," but mythology only an excuse for exploring luminous atmosphere.

1650

Bernini: Curtain Up!

Before age 20, Bernini is acclaimed a virtuoso sculptor. Charming and politically adept, he goes from triumph to triumph, a favorite of popes and Louis XIV. Not only precocious, Bernini is an omni-talented multi-tasker. He takes all art forms for his purview. He writes poetry, produces plays and operas, even designing sets and costumes. His architecture is like a stage set, combin-ing theatrical lighting, vast scale, and lavish gilding. He ramps up Renaissance principles to major drama.

1656–67 Also master architect, Bernini designs piazza outside Rome's St. Peter's Basilica as double colonnades curved to embrace pilgrims like, he says, "the motherly arms of the church." Composition radiates from central obelisk inside 650-foot-long oval, surrounded by monumental galleries of quadruple columns, topped by entablature with 140 statues of saints. Grandiose effect awes visitors with glory of church.

1656 Considered one of finest paintings ever, Velázquez' "Las Meninas" is his most complex work, an interplay of appearance and reality combining figures in a mirror, framed by a doorway, within other paintings, and in groups, all anchored by a grid of intersecting rectangles. "Las Meninas" refers to maids tending central figure, 5-year-old daughter of king (who, with queen, is seen in mirror). Note figure groups arranged in overlapping triangles, balancing composition while seeming spontaneous. Lower half of canvas is all portraits, including self-portrait of artist, while top half is space filled with range of light and dark; uses aerial and linear perspective for sense of distance.

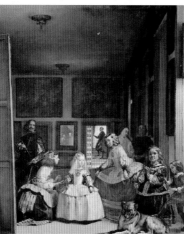

c. 1665 Ruysdael excels at poetic landscapes dominated by trees, depicting both enveloping atmosphere and tiny detail. "Landscape with Shepherds and Peasants" uses strong forms and vigorous brushwork for emotional force. Heroic tree links terrestrial world of humble human beings with vast, over-arching sky—dramatic mood of wind-swept clouds, patches of light and dark.

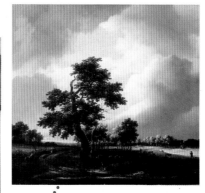

1656–61 Greatest French landscape designer Le Nôtre creates formal garden of clipped boxwood parterres at Vaux-le-Vicomte château. Geometrical design complements building's form, while main axis leads eye to distant vista, crossing canal and descending in series of gardens, ponds, trees, and statues. Le Nôtre later transforms barren site of Versailles into massive park with fountains, grottoes, avenues, lakes, and woods. Greatest talent for creating sweeping vistas that incorporate natural features like different levels of terrain and surprises to delight the eye.

Spain's Golden Age

Spain explodes with Counter-Reformation zeal to reinvigorate the Roman Catholic church after Martin Luther discredits it. Art is an essential weapon to win back congregants, and it employs diverse weapons: mysticism and sensuality, as well as extreme realism and asceticism. Titian's influence is evident in rich color and technical mastery, whether in religious paintings, portraits, or still lifes. Like Velázquez's portrait of Pope Innocent X, proclaimed by its subject "*troppo vero*" (too truthful), Spanish masters like Ribera and Zurbarán excel at visual realism.

1665 Vermeer's "Head of a Girl" (also known as "Girl with a Pearl Earring") is a masterpiece of Dutch art. Luminous scene focuses on simple subject, with light almost palpable. Each element essential to overall effect of intimacy, dignity, calm. Sitter is frozen for eternity, turning towards viewer, defined by light falling from upper left on distinctively blue head scarf and softly sparkling pearl. Intensity of color varies with distance from light source; dots of impasto (thickly applied paint) create raised surface for 3-D texture and increased reflection.

1666–80 Cupola of dome at Church of San Lorenzo in Turin by Guarini is network of intersecting ribs weaving together voids and volume. Exciting spatial flair and structural ingenuity derive from architect's training as mathematician. He creates unprecedented cone-shaped dome, with semicircular arches interlocking to form octagon atop circular drum.

1669–88 Louis XIV's Versailles, designed by Le Vau and Hardouin-Mansart, epitomizes spectacular scale of Baroque architecture. Over quarter-mile long, straight lines and paired columns give impression of imposing mass and stability. French Baroque leans heavily on Classical motifs, more restrained than Italian but equally opulent in décor. "The symmetry, always the symmetry," the king's mistress complains.

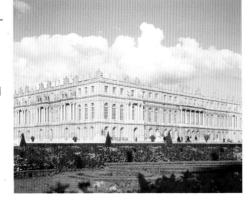

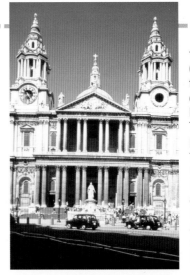

1675–1708 Wren's St. Paul's Cathedral introduces dome to English architecture, with central Classical dome flanked by fluid Baroque towers. Two-tier elevation of pedimented temple front forms base for massive, unified appearance. Wren is mathematician, astronomer, and scientist who converts love of geometry into inventive architecture. St. Paul's synthesizes Renaissance stability and Baroque swing.

c. 1678 Hardouin-Mansart and Le Brun's Hall of Mirrors at Versailles exemplifies rich materials, blend of painting, sculpture, architecture; and monumental majesty of Baroque era. Barrel-vaulted, painted ceiling arches over 17 windows on garden

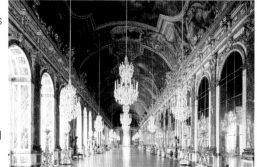

side. Opposite, 17 mirrors abut marble pilasters with gilded bronze capitals. Furnishings of solid silver, later melted down to finance wars, originally transformed 240-foot-long hall into shining corridor.

1705–22 Vanbrugh's Blenheim Palace, designed with English traits of spiky profile and weighty mass, blends Renaissance Classicism (porticos and symmetrical colonnades) and Baroque theatrical flair. Behind vast entrance court stands central pedimented portico and four corner towers adorned with fanciful lanterns. Titanic scale and copious ornament reflect personality of flamboyant architect, also a witty playwright, who says he wants his structures to be "masculine," with "something of the Castle Air."

1700

Living Large

Louis XIV, France's self-proclaimed "Sun King," is not, an English observer says, "the greatest king, [but] he was the best actor of majesty that ever filled the throne." Versailles is his stage, impressing subjects and visitors with its beauty, splendor, and unmatched scale. Hundreds of rooms house the royal family and 5,000 aristocrats, stables shelter 12,000 horses, the live-in staff numbers 14,000. Gardens radiate like sunbeams from the palace's midpoint, where the king's bedroom is located. The Grand Canal is one mile long, and 1,400 fountains animate the exterior, softening the taut symmetry of the château and gardens.

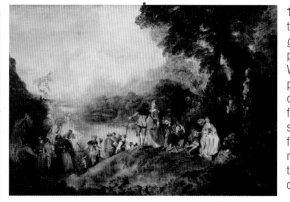

1717 Watteau's "Embarkation to Cythera" exemplifies *fête galante* (elegant party), popular subject for painting. Watteau caters to nobility, portraying frivolous pastimes, often set in nature, with dainty figures representing high society. Pastoral scene saved from Rococo triviality by murky, autumnal mood, adds to grace and sense of evanescence of youth and love.

c. 1725 Canaletto's "Grand Canal near the Campo San Vio" is typical *veduta* (view) of Venice, artist's specialty that serves as early version of postcard. His picturesque views employ vivid contrasts of light and shade, high-keyed colors, smooth finish. Topographically accurate, they present scene with unparalleled exactitude, so viewer can locate actual site.

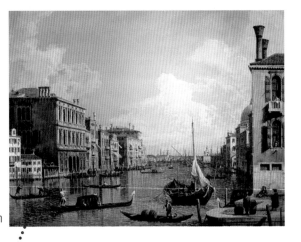

1735 Domed ceiling of Reception Room in Prince-Bishops' Residence by Balthasar Neumann shows German mastery of Rococo movement and fantasy. Ceiling fresco by Tiepolo (1752) and luminosity of windows at base of dome complement gilded stucco for impression of magnificence. Structure disappears under coating of ornament, so experience of space and light, not mass, dominates.

Begun 1734 British architects Burlington and Kent combine elements of Palladio, Rome, and Inigo Jones in country manor Holkham Hall. Fad for Italian style seizes England, toning down Baroque ostentation into sedate, tasteful refinement that mirrors Enlightenment stress on reason. Kent rejects geometric artificiality of French garden, designs first "natural" (English) garden reflecting Romantic mania for picturesque landscape.

1734–39 Cuvilliés' Hall of Mirrors in a hunting lodge is an outstanding example of French Rococo style, taken up with gusto in Germany. Forty-foot-diameter circular room is lined with glass to dissolve walls. Carved wood and silver swags decorate the coolly blue walls in graceful arabesques, with floral ornament replacing Classical. Carved stucco motifs of harps, violins, butterflies, and birds lend airy, hedonistic feel. Oddly, roof of frou-frou pavilion serves as platform for shooting pheasants.

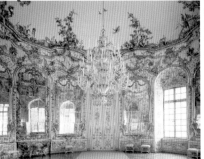

Rococo: Blithe Spirit

Rococo finds its greatest expression in interiors, where it incorporates gaiety and laughter in solid form. Reacting against the strict symmetry and severity of French Baroque style, aristocrats seek solace in the delicate curves and flowery forms of Rococo. By the mid-1700s the style spreads throughout Europe, characterized by cream and pastel colors, lavishly gilded. Wispy, lacy tendrils of carved stucco loop around cornices, converting interiors into bowers of ornament.

1745 Gainsborough's "Conversation in a Park" probably portrays the artist and his wife, shows debt to Van Dyck with elegant, elongated figures in casual pose and fancy dress. Gainsborough adds vitality of nature to British art. Demand is only for portraits, so he inserts leafy landscape as background. Baroque swirls of foliage echo crumpled folds of satin skirt.

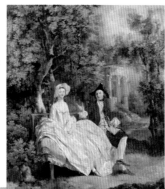

1746–57 Rococo organ loft designed by Zimmermann Brothers in Bavarian church is like confectionary wedding cake, delicate as porcelain, frosted with gilded ornament against white background. Interior of pilgrimage church merges lyrical gaiety with deep piety, aesthetic unity.

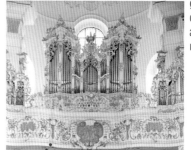

1745 In Hogarth's engraving from his "Marriage à la Mode" series, a dissolute young noble returns from a night of debauchery, his wife yawns after a late card party, and their disgusted steward walks out. Hogarth's satirical prints caricature the foibles of British snobs and reveal the inequities of London life. A sly wag, Hogarth paints a lace cap in the newlywed husband's pocket, hinting at adultery.

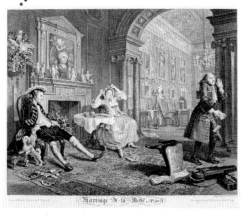

1744–60 Borromini's influence on Fischer von Erlach is clear in Baroque façade of Church of the Holy Trinity in Bavaria. Classical elements like engaged columns make ovoid-shaped, central structure curve in and out, flanked by imposing towers. Dynamic sculptural handling synthesizes sacred and imperial might.

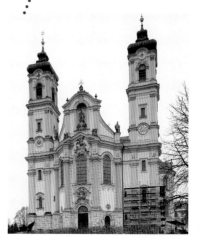

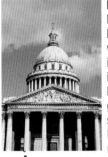

Begun 1758 French Neoclassic style reaches its height in Soufflot's Panthéon, which combines monumentality and Classical motifs of imperial Rome with structural lightness of Gothic style. Firm geometry of domed and apsed spaces resembles Roman baths, but design becomes more spare, with return to post-and-lintel support. Columns again bear weight, lines become cleaner, simpler, an honest expression of structure.

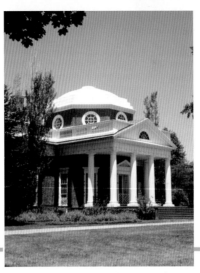

Begun 1775–6 Scottish-English architect Robert Adam designs Neoclassic interiors for Osterley Park House, like painted chimney board inspired by Pompeii frescoes. Adam stylizes antique motifs in highly decorative patterns that improvise on ancient source. His airy, playful designs produce effects, he says, "of great novelty, variety, and beauty." Light moldings, graceful ornament, painted wall patterns look like glittering embroidery.

After 1765 Boucher's "Three Graces Carrying Amour, God of Love" is typical French Rococo painting. Fashionable, mythological scene displays charms of sensual female nudes' pearly bodies. Vivid color, lively lines in curves and counter-curves, and *joie de vivre* permeate his works. Boucher celebrated for glorifying female form.

Begun 1769 Palladian Neoclassicism comes to America with Thomas Jefferson's Monticello. Service wings flank a central block with pedimented, two-story temple façade. Dome, based on Temple of Vesta, is first in colonies. Roofs form viewing terraces, departure from Classical precedent so dear to his heart. An avid inventor and experimentalist, Jefferson installs gadgets to open shutters, revolving service doors, disappearing beds, creates museum out of entry hall to display fossils, buffalo head.

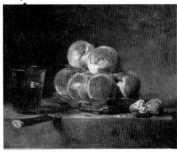

1768 Chardin's "Basket of Peaches" shows French realist painter's expertise in still life. Simple composition of wide-based triangle, plain background, horizontal arrangement highlighted by vivid colors, radiant illumination. Cantilevered knife leads eye to focal point. Elements have humble monumentality, harmonious unity. In this, his last known still life, Chardin renders peach fuzz with near-tactile accuracy.

Pure geometry

1783 French architect Boullée proposes this funerary monument for Isaac Newton based on the sphere. His

schemes for impossible buildings show his love of pure geometric forms like the pyramid, cylinder, and cone. This giant hollow sphere, "the image of perfection," he says, symbolizes the universe.

1780 In Ledoux's hands, Neoclassicism means not slavish imitation but license to experiment. His Director's House at a French salt factory stacks square and cylindrical segments to re-envision the column. Most daring architect of his time, Ledoux unleashes his imagination, creating forms of startling originality and

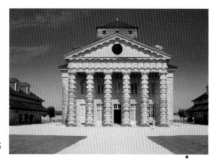

expressivity. (He ornaments buildings at La Saline with carved stone "gushing" salt water.) Although revolutionary in his profession, as Architect to the King, his career ends with 1789 French Revolution, when he's sent to prison.

1773 In "Three Ladies Adorning a Term of Hymen," Reynolds idealizes his subjects, the Montgomery Sisters, portraying them as Classical figures posed beside antique statue. Painting is commissioned as engagement portrait of central figure, seen as worshiping Hymen, mythological god of marriage. Reynolds adds Roman trappings, cleverly converting contemporary subject into prestigious history painting.

1779 Charles Willson Peale, model Enlightenment man, is saddler, silversmith, watchmaker, and upholsterer before becoming most popular portraitist in America. A prolific inventor, he founds first natural history museum, excavates mastodon skeleton, and paints Founding Fathers of new republic. "George Washington after the Battle of Princeton," painted from life, establishes hatless Washington as democrat and patriot, refreshingly free of Old World gew-gaws.

Neoclassical Architecture: Rome Rises

Extravagance has a short shelf life, and trend-setters tire of Rococo frills around 1750, as Enlightenment thinkers stress clarity, reason, and Neoclassical purity. Influenced by etchings of Roman ruins and excavations of Pompeii and Herculaneum, an antique vogue spreads. Pure geometric forms take over; buildings are solid, severe, with Classical orders used for support, not applied as decoration.

Neoclassical Art

Neoclassical art strips away Rococo frippery for an austere approach, with subjects derived from antiquity. In sculpture, idealized figures in the Classical style, wearing togas and powdered wigs, are all the rage. The Enlightenment preaches reason and logic; and painting assimilates the orderly virtues of clear, balanced compositions, Greek and Roman trappings, coupled with "ennobling" themes. The German writer Goethe sums it up: "the demand now is for heroism and civic virtues." No more mirthful party scenes. Ancient history, mythology, and pompous posturing are the rule.

1780–84 Copley's "Self-Portrait" shows skill of first great American painter. Self-taught, he transcends crude artisanship by studying anatomy books and reproductions of famous paintings. Achieves technical mastery of skin tones, rounded forms, and simulated effect of light on differing materials. Gestures and subtle expressions reveal character, showing not idealization but individuality of sitter.

1790 Vigée-Lebrun's "Self-Portrait" illustrates charm and beauty of painter, friend of Queen Marie-Antoinette. Excels in candid, expressive portraits of royalty and aristocrats, executed with grace, vivid color, delicate lines. One of first women to succeed as court painter, she works tirelessly, writes in memoirs: "on the day that my daughter was born I never left my studio and I went on working . . . in the intervals between labor pains." Style mixes Rococo (reflecting fluffy taste of *ancien régime*) and Neoclassical starch.

1784 Art, David says, must "contribute forcefully to the education of the public." In "Oath of the Horatii," three stalwart brothers swear to defeat Rome's enemies, their upright contours contrasted to swooning women, all limp curves. Male figures (inspiring emblems of stoic self-sacrifice) are arranged like statues in antique setting. Propagandistic art should "plant," David says, "the seeds of glory and devotion to the fatherland." David's most adamant dogma: color within the lines (as opposed to Romantics, who say color, not line, is essence of art).

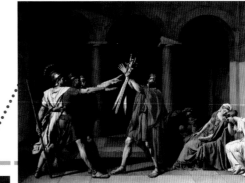

Fonthill Abbey

Begun 1795 James Wyatt designs Fonthill Abbey as a mega-version of a medieval Gothic abbey for an eccentric millionaire client. The home includes a 276-foot-tall tower, 8 miles of 12-foot walls, and 300-foot-long corridors. The residence is constructed like a cathedral in the shape of a cross with a central octagonal hall 120 feet tall. The mania for Gothic reaches ludicrous heights; the doors are 35 feet high. This over-reaching building crashes in 1825, but the Gothic Revival continues its ascendancy.

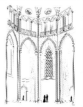

1794–95 Utamaro's "Painting the Lips" is color woodblock print from Japan's Edo period. Secular prints (like Western pin-ups or posters of celebrities) record members of *ukiyo*, or the "floating world," like lovers, actors, or beautiful courtesans. Buddhism teaches worldly joys are fleeting, but artists suggest they should be savored to the fullest while they last. Utamaro chooses squatting pose, focusing on woman's intent expression, to give her individuality. Flat tints, high-keyed color, abstract detail of woodblock prints highly influential in West during 19th century.

Neo-Gothic Craze: Haunted Mansions

Gothic novels set in dank, dismal castles, replete with ghosts wafting about, incite a rage for Neo-Gothic homes. Everything from cottages to castles is draped in sham crenellated walls, with towers and turrets galore. Horace Walpole even furnishes his living room with a tomb, for that final-resting-place touch. Architects cultivate the thrills and chills of the Sublime, rejecting reason and seeking sensation in gloomy dwellings with rough, asymmetrical lines.

c. 1794 Romantic poet William Blake known for mystical watercolors like "Glad Day, or Dance of Albion." Specializes in imaginative figures drawn from visions and personal mythology. Creates disturbing images of phantasmagoric creatures as allegories, depicts battle between good and evil. Considers his paintings prophecies from inner world of spirit. His figures idiosyncratic, in linear style that blends lettering and illustration, fraught with earnest symbolism.

c. 1797 Great Spanish painter Goya fits into no school, a court painter but he remains his own man with singular vision and technique. He pioneers use of loose brushstrokes for accurate, expressionistic representation. His version of realism satirically conveys inner character, as in doltish portrayals of royal family. *Los Caprichos*, collection of 80 etchings on the idiocy of mankind, includes "The Sleep of Reason Produces Monsters," harrowing indictment of humanity's cruelty.

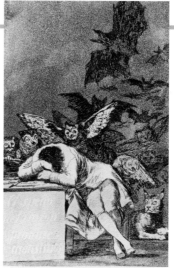

The Nineteenth Century: Age of "Isms"

A nineteenth-century art teacher instructed his pupil: "The history of art is easy. There are the Greeks, there's Raphael, there's Monsieur Ingres, and there's me." At the outset of the century, art was smugly smothered in traditional authority.

Students at the French Academy of Painting and Sculpture and the Royal Academy in England learned to draw from casts of classical statues and nude models posed like antique statues. Official taste sanctioned a hierarchy of genres, with biblical, mythological, and historical subjects at the top. The *crème de la crème* were heroic nudes, adorned with helmets, crowns, or swords. They posed amid convincingly accurate Roman scenery and golden Tuscan vistas.

Technique was just as strictly regulated. Art should be narrative, instructive, and elevated in tone, with figures drawn to convey an idealized, allegorical message. Neoclassic art was symmetrical, highly finished, and marked by consummate draftsmanship. Ingres—master of the static, clear, and coolly elegant—confided the secret to his admirer Degas: "Draw lines, young man, many lines—from memory or from nature—and it is in this way that you will become a good artist."

But the line of continuity with the past soon shattered. Neoclassicism and the Enlightenment's love affair with reason gave way to the emotion and drama of Romanticism.

Prior to the 19th century, an art movement prevailed for centuries, reflecting the stability of church and state. But now, the Industrial Revolution and political revolutions were in full swing. Following the example of the U.S. and France, a cavalcade of countries overthrew colonial rule. With social and political institutions in flux, art movements became cyclical. Like the rapid advance of science, technology, and urbanization in the 19th century, the pace of artistic innovation vastly accelerated.

The poet Baudelaire claimed that each age forges its unique form of beauty derived from intangible cultural currents. Artists defined their times by expressing these currents. When the calm uniformity of Neoclassic art appeared out of step with such a dynamic age, art entered an era of rapid evolution.

Romanticism, heralded by Géricault and Delacroix in France and Turner and Constable's landscapes in England, dominated the first half of the century. "Painting is with me but another word for feeling," as Constable said. The artist's imagination, intuition, and emotion translated into high-keyed color, loose brushstrokes, and plunging diagonals to express a subjective vision.

Around mid-century, artists like Courbet, Millet, and Daumier took another tack called Realism. They portrayed the lower classes

with as much dignity as a Roman senator. They painted grimy stonecutters and ragged peasants, unglamorous subjects who'd before been deemed unworthy.

The advent of photography soon stole Realism's thunder, liberating artists from their historical task of documenting appearances. Manet sounded a new, anti-Academic rallying cry: "We have been perverted by the recipes of painting. How to rid ourselves of them? Who will give us back the simple and the clear, who will deliver us from all this prissiness?"

Impressionists like Monet, Renoir, Sisley, and Pissarro answered his call. Building on the Barbizon School's practice of sketching outdoors, they began producing paintings *en plein air*, focused on capturing transient effects of light.

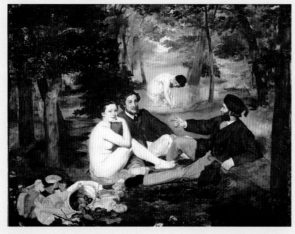

The public reacted with outrage— to Manet's contemporary subjects and to the Impressionists' rapid, broken brushstrokes, flecks of bright color, and forms that seemed unfinished, as if dissolving into atmosphere.

In sculpture, a parallel revolution occurred. Canova's Neoclassic marble deities had "a noble simplicity and calm grandeur." Now Rodin, Medardo Rosso, and Augustus Saint-Gaudens opened up sculpture, transforming the ordinary into the monumental and adding psychological expressiveness. Without evoking a subject's inner essence, Rodin said, "how could the joy or the sorrow of an inert object—of a block of stone—affect us?"

The Post-Impressionists were more an attitude than a school of art. They had in common a lust to experiment and a quest for personal expression. Gauguin fled to Tahiti to escape "the disease of civilization," which he defined as "everything that is artificial and conventional." Cézanne turned his x-ray vision on objects in his zeal to reveal underlying structure. The writer Zola defined a work of art as "a corner of creation seen through a temperament."

Van Gogh, too, flew the rebel flag: "I should be in despair if my figures were 'correct' in academic terms," he proclaimed. "I don't want them to be 'correct'." A parade of iconoclastic art movements—Symbolism, Aestheticism, Expressionism, and Art Nouveau— concluded the century.

Interior experience, not exterior appearance, became the prime subject for art. The poet Mallarmé summed up the new approach: "Paint not the thing, but the effect it produces."

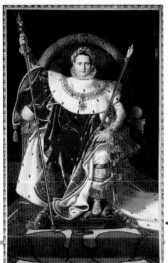

1806 Supreme advocate of purity of line, Ingres idealizes Napoleon as a combination of Greek god, crowned by laurel, and triumphant Roman emperor on throne. Ingres, David's pupil, detests Romantic mandate to build form with color, filtered through emotion. He champions meticulous, Academic style with glassy-smooth surface "like an onion skin." Ornamental details as important as facial features for master draftsman.

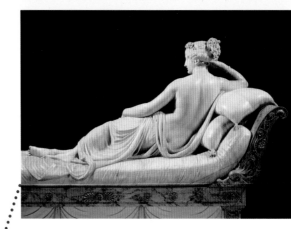

1808 Most well-known Neoclassical sculptor, Canova portrays Napoleon's sister, Pauline Bonaparte Borghese, in idealized, antique style as Venus. Nude pose modeled on Titian painting, while body and drapery come straight from Greek statue.

1805 Stuart specializes in portraits of U.S. founding fathers. His virtuoso technique avoids mixing colors, which he says makes skin look like "buckskin." "Thomas Jefferson" dispenses with background, shows no-nonsense, American style focusing on subject's character ("nails the face to the canvas," Benjamin West says). Creamy skin tones blush with life.

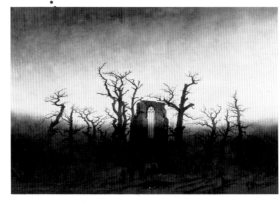

1809–10 German painter Friedrich imbues landscapes with haunting melancholy and shows Romantic concept of nature as sacred. Irradiated by misty moonlight, "Abbey in Oak Forest" depicts Gothic church ruins, ringed by bare trees, welcoming worshipers to mourn vanished past.

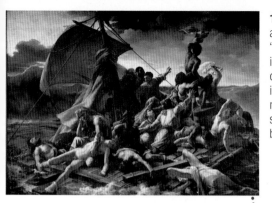

1819 Géricault expresses horror and hope of shipwrecked crew in "Raft of the Medusa." Dramatic lighting, dynamism of poses, tension of bodies, and macabre expressions illustrate passion of Romantic movement. Agitated figures, swirling motion, and energetic brushwork convey desperation.

The Romantic Revolution

Poets like Wordsworth, Byron, and Shelley revolt against the Age of Reason. Visual artists take up the banner of subjectivity, feeling, and imagination, defying Academic dictates on subject matter and technique. Line vs. color, or Realism vs. Romanticism, is the battleground. Artists like Delacroix and Géricault lead the way, using vivid, loose brushstrokes to suggest a maelstrom of emotion and their singular vision.

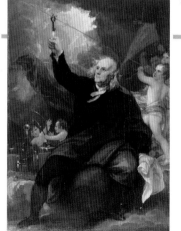

c. 1816 West is first American painter to gain international acclaim. Paints scenes from history like "Benjamin Franklin Drawing Electricity from the Sky," but breaks with Neoclassic convention by garbing subject in modern dress.

Begun 1822 Soane, one of most original English architects, strays from Neoclassic style into picturesque, personal quirks. Entrance of Pell Wall House uses Roman dome, arches, vaulting but with eccentric spatial and lighting effects.

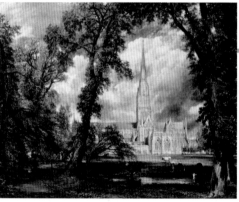

1823 Constable paints everyday scenes of English countryside, like "Salisbury Cathedral," reflecting his love of nature and down-home, humble spirit.

Working outdoors, he captures flicker of light and shifting clouds—the actual feel of weather. Innovative brushwork simulates sunlight with specks of yellow or white paint. Rejects Italianate landscape tradition requiring "golden-hued" grass (the Academy taught that paintings had to be covered with varnish, which gave grass a yellowish appearance) instead of green.

c. 1826 French chemist Niépce invents first photographic process, called heliography, to fix image projected from early camera onto polished pewter or silver plate, after exposure of many hours.

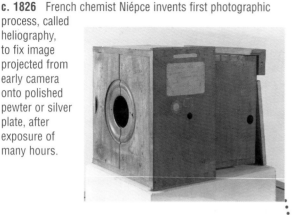

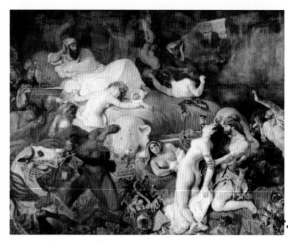

1827 Foremost French exponent of Romanticism, Delacroix paints lurid subjects like "The Death of Sardanapalus," depicting massacre of Assyrian king's concubines. Turbulent scene reeks of Baroque excess and dynamism, combined with Rubenesque sensuality. Sharp contrasts of light and dark, vivid colors create sensational effect.

1824–28 Schinkel designs Altes Museum in Berlin with Neoclassic façade. Bold parade of

Ionic columns masks central rotunda modeled on Pantheon. Building embodies pomp and gravity of state's mission to educate and uplift through art.

1826 Leading painter of Hudson River School, Cole takes up Romantic mantle in dewy landscapes shimmering with light. His pastoral "Scene from the Last of the Mohicans" suggests that primeval grandeur of American wilderness is superior to Old World decay.

1829–30
Pennsylvanian Hicks is sign painter and preacher before using paint as his pulpit in scenes illustrating Quaker pacifism. "A Peaceable Kingdom with Quakers Bearing Banners," portrays, in "primitive" or folk-art style, Biblical prophecy of species living together in harmony.

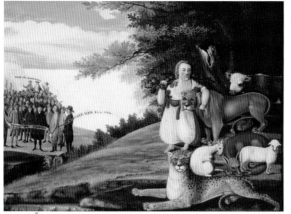

1834
Daumier, believing art should "be of its time," ushers in realism with his pitiless caricatures denouncing official cor-

ruption and supporting the lower classes. Lithograph of "Rue Transnonain," printed in weekly newspaper, shows innocent family butchered by French soldiers, becomes rallying cry against oppression.

Hudson River School: Luscious Landscapes

Attracted by the radiant light and serene majesty of virgin scenery in the Hudson River Valley, Catskills, and Adirondack Mountains, painters including Cole, Durand, Kensett, and Gifford raise atmospheric landscapes to a peak of popularity. Around the mid-19th century, inspired by patriotic pride, they produce rapturous images of the unspoiled wilderness, in opposition to the prevailing style of portraits and history painting.

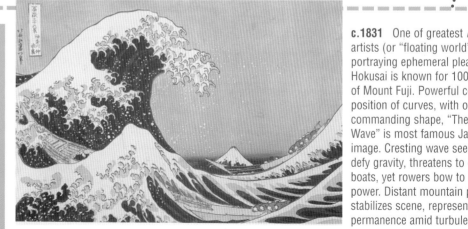

c.1831 One of greatest *ukiyo-e* artists (or "floating world" portraying ephemeral pleasures), Hokusai is known for 100 views of Mount Fuji. Powerful com position of curves, with one commanding shape, "The Great Wave" is most famous Japanese image. Cresting wave seems to defy gravity, threatens to engulf boats, yet rowers bow to its power. Distant mountain peak stabilizes scene, represents permanence amid turbulence.

c. 1835 Self-taught, itinerant artist Phillips paints portraits throughout New England. His simple style emphasizes strong colors, decorative lines, and figures placed against dark backgrounds. Uses symbols as clues to character, such as dog representing fidelity and strawberries as emblems of youth in "Girl in a Red Dress."

1840

c. 1845 Daguerre, who invented the process of fixing an image on silver-coated copper after a 30-minute exposure in 1839, makes portrait of his wife Madame Louise Daguerre. Daguerreotypes are so precisely detailed, they're termed "divine perfection" when introduced. Invention changes course of pictorial representation, used both to record reality and as medium of expression.

1843 Talbot makes salt print from paper negative to document erection of Lord Nelson Column in London's Trafalgar Square. To make "the art of photogenic drawing" practical, he patents the calotype, first negative-to-positive process that allows duplicating copies of an image on paper.

Folk Art: Power to the People

Folk, or "naïve," art refers to functional and aesthetic objects made by those without formal training, often artisans or those called "outsider artists" driven to create images of their visions. It includes utilitarian articles like quilts or weathervanes and craft objects like carved figure-heads for ships. The pieces, often rough-hewn, simple, and stiff, lack realistic perspective but express the maker's local heritage forthrightly, with great charm. Although painted figures may look flat, typically folk art exhibits lively, decorative design and eye-catching color.

New Art Form: Photography

When Talbot pioneers prints on paper and Daguerre succeeds in capturing an image on a silver-coated plate (called "the mirror with a memory"), a new art form for the Industrial Age is born. A rage for photographic portraits sweeps Europe and the U.S., causing artists to prophesy, "From today, painting is dead." Early photographers first document reality objectively, then mimic painting styles. Gradually, they develop an aesthetic adapted to the new medium, using lighting and composition to express more than appearance.

1840–60 Romantic nostalgia and craze for past influence Barry and Pugin to design London's Houses of Parliament in Neo-Gothic style. Asymmetrical skyline facing Thames River bristles with pointed, perpendicular accents. Interiors are Gothic in most minute details— from inkstands to hat stands.

Completed 1847 Smirke champions Greek Revival in design of British Museum's massive Ionic colonnade. Pediment boasts sculpted frieze like Parthenon, but building is restrained, austere. "When art chooses to frolic in masonry," he asserts, "the effect is not only unnatural but indecorous."

1844 In "Rain, Steam, and Speed," British painter Turner contrasts locomotive's blur of speed and power to pre-Industrial-Age boaters in front of arched viaduct, left behind in their static idyll. Artist innovates atmospheric rendering of scene through loose brushstrokes, veil of paint, which present his interpretation of subject more than factual appearance.

Begun 1848 Washington Monument, Mills's 555-foot-high obelisk, shows revivalist spirit in mid-19th century. When completed in 1884, one critic sees "a stalk of asparagus," while for Mark Twain, "it has the aspect of a factory chimney with the top broken off." Sheathed in marble, it is highest all-masonry structure in the world, a pure, geometric form.

63

1850 As American settlers push Westward, artists portray sublime landscapes beckoning, soaked in welcoming beauty. In Church's "Twilight," luminous landscape symbolizes shining national identity, implying God's blessing. Lovingly detailed, grand style and epic scope make Church preeminent Romantic landscape painter.

1849–50 Assaulting the barricades of both Romanticism and staid Academic style, Courbet pioneers Realism, presenting humble folk in everyday scenes with direct honesty. Refusing to paint an angel for a church commission, he declares: "Show me an angel and I will paint one!" When "Burial at Ornans" exhibited, viewers accustomed to ethereal history paintings term it coarse, but Courbet invests the ordinary with force and dignity.

1849 Bonheur's "Plowing in the Nivernais" portrays her favorite subject—animals—in naturalistic style. An early French feminist, she insists on equal rights for women, smokes in public, rides astride rather than sidesaddle, often dresses as a man to gain entrance to places excluding women. Excels at rendering of animals in motion, integrated with landscape.

Realism: Art of the Visible

"Painting," Courbet insists, "consists of the presentation of real and existing things." Realism in art is a reaction against both the Neoclassic style that decrees subjects of paintings must derive from history, mythology, or the Bible and against Romanticism's misty-eyed, beauty-hyped views. Opposed to idealization, Realists portray down-to-earth subjects naturalistically, showing what Baudelaire calls the "heroism of modern life."

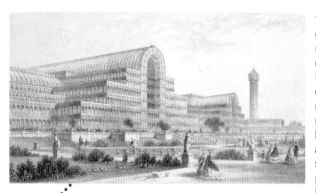

1851 Former gardener and greenhouse designer, Paxton uses new system of glass and metal construction in Crystal Palace, London exhibition hall. Since all components mass-produced in six months, then assembled on site, radical design of 1,800-foot-long building represents new era in architecture. First prefabricated, standardized, industrial building is prototype of modern style without historical ornament.

Barbizon School

French painters like Corot, Millet, Rousseau, and Daubigny, inspired by the scenery around the Forest of Fontainebleau, elevate landscape painting to prominence, rejecting the official canon that deems it an inferior genre. The artists advocate painting outdoors, direct from nature, although they complete the sketches in indoor studios. A romantic reverence for nature, in reaction against increasing urbanization, informs their work.

1855 Corot's "Diana Bathing" exemplifies signature style suffused with silvery tones, filtered light, delicate, olive-green leaves for soft, poetic effect. Intimate landscapes often feature mythological sprites. Conveys tranquility through clarity, purity, simplicity of scenes.

1857–59 Millet, who comes from a peasant background, romanticizes rural life by portraying peasants as dignified figures of heroic virtue. "The Angelus" shows a couple pausing amid their labor in the field as church bells toll for prayer. Drab colors and barren fields suggest hardship of lives of the poor. Millet's concern is to make "the trivial . . . sublime."

Begun 1857 One of most lavish buildings of century is Charles Garnier's Paris Opera, a gilded gem of Beaux-Arts (paired columns is hallmark) and Second Empire style (mansard roof is main tip-off). Garnier designs interior, including Grand Stairway, as regal stage for spectators. Sumptuous marbles, chandeliers, statuary, and ornate columns create mood of animated euphoria. Garnier uses polychrome décor, mirrors, and lavishly carved stonework to harness "the magical power of art."

Baron Haussmann scores a coup when, in redrawing Parisian boulevards on a grand scale, he places the Opera House designed by Garnier as the culmination of a vista. The building's exterior is a symphony of sculpted mass, with solids and voids in harmonious rhythm. The first floor layout maximizes social circulation and vivacious interaction. A student of antiquity and lover of the Baroque, Garnier insists on dignity, saying, "Although art can dance the gavotte or minuet, it must refrain from the can-can."

Plan, Ground Floor,
Palais Garnier

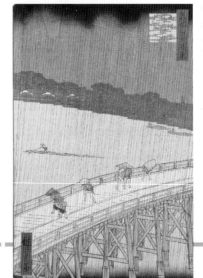

1857 Hiroshige's prints from his series "100 Views of Edo" (Tokyo) are so popular the woodblocks wear out and must be re-carved. "Squall at the Large Bridge Ohashi" depicts road between old capital Kyoto and new capital of Edo, traveled by Japanese of all walks of life. Prints used like souvenir postcards of journey but also embody spirit of country, landscape, and seasons. Shows all social classes on road of life, celebrating both nature and human nature. Human figures persevere through storm, accepting role in universe.

Architecture's Industrial Revolution

19th-century architects continue to slap Roman, Greek, and Gothic frills on buildings, but novel technology and new materials like wrought iron, steel, and plate glass indicate changing times. The Industrial Revolution requires new building forms like train sheds, factories, iron bridges, and department stores, heralding an age of metal-frame (rather than masonry) support.

1862 Burne-Jones shows fascination with historical tales in "Fair Rosamunde and Queen Eleanor." Elongated figures have static gravity as in medieval carvings. His idea of a painting: "a beautiful romantic dream, of something that never was, never will be —in a light better than any that ever shone"

c. 1860 Nadar photographs celebrities like Sarah Bernhardt. Goal: to render "not an indifferent plastic reproduction . . . but the intimate resemblance . . . the psychological side of photography." Pyramidal composition with voluminous drapery at base culminates in expressive face of famous actress.

1863 Morris glorifies manual labor, advocating that an artisan should both design and execute works like textiles—weaving, printing, and dying them by hand. His "cherries" wallpaper design for dining room is aesthetic success, but ideal of handmade art for the masses fails, since works prove too laborious and expensive to produce commercially.

The Pre-Raphaelite Brotherhood Meets Arts and Crafts

With Raphael's paintings all the rage, a group of British painters including Millais, Hunt, and Rossetti reject the slick perfection of Academic art. Calling themselves Pre-Raphaelites, they declare their allegiance to the simple "purity" and sincerity of medieval art. Their symbol-laden, moralizing tableaux dramatize mythological subjects and reflect nostalgia for a simpler, pre-industrial era. A second generation of artists sharing this literary bent includes Morris and Burne-Jones, pioneers of the Arts and Crafts movement that calls for hand-crafted goods of high quality, such as those produced by medieval guilds. Art, Morris holds, is "man's expression of his joy in labor."

1863 Manet's "Déjeuner sur l'Herbe" arouses scandal due to unconventional treatment of classic subject. Nude's brazen gaze outrages viewers, and, instead of picnic set in mythical past, male figures wear contemporary clothes. Manet's modern interpretation fulfils Baudelaire's call for "the true painter" who can "make us see and understand . . . how great and poetic we are in our neckties and our patent-leather boots."

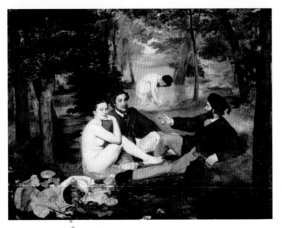

1860

Rebel with a Cause

Besides his "immoral" choice of subjects, Manet also opposes traditional practice in technique. His sketchy brushwork, flat colors, hard outlines, and abrupt transition from light to dark without modulated tones startle eyes used to subtlety. His treatment of light is revolutionary in the sharp contrasts of pale patches reflecting light and dark areas absorbing it. This insistence on a new art for a new age makes him the hero of contrarian artists and earns him star status in the *Salon des Refusés* exhibition, where artists like Cézanne and Pissarro exhibit paintings rejected by the official Salon.

1864 In "Brace's Rock, Brace's Cove," Lane renders Massachusetts scene in spare composition stressing luminous atmosphere. Boat's mast leads eye toward still horizon, creating elegiac mood of taut stasis. Foreground meticulously detailed, while distant background a soft glow.

1866 Gifford explores light and color in misty sunrise picture titled "Morning in the Hudson, Haverstraw Bay." Tints of sky and water, reflections in bay dissolve individual elements in overall blur of subtle color. Lane, Gifford, Kensett, Heade, and Bricher comprise mid-19th-century school of landscape painting called Luminism, in which effects of light are paramount.

1866 When her children give her a camera in 1864, at age 48, Cameron takes up photography. She aims, with Victorian earnestness, to portray nobility of her human and mythological subjects, posed melodramatically and in sentimental soft focus. Vivid, psychologically intense portraits, like "Beatrice," combine real and ideal, expressing passion and poetry of her time. She describes her "tender ardor" for her camera: "it has become to me as a living thing, with voice and memory and creative vigor."

c. 1867 Brady's photograph of Walt Whitman shows poet in relaxed pose with sprig of greenery in pocket signaling love of nature. Brady makes his name as documenter of Civil War, exposing more than 7,000 negatives. Since impressions require 3 minutes to register on plate, Brady records battlefields, soldiers posing stiffly in camp, and corpses in trenches. Brings home horror of war, inspiring Abraham Lincoln's Gettysburg Address.

World in Transition

The shape of things to come appears in the new industrial structures in which functionality is supreme. The 1850s–70s are a Cast-Iron Age, in which engineers hold the key to progress in architecture. *"Du fer! Du fer! Rien que du fer!"* (Iron, iron, nothing but iron!) Baron Hausmann demands as he redesigns Paris. The need for train sheds covering vast space, constructed of fireproof material, led to mass-produced metal parts and ever-larger sheets of glass. The enclosed space and scale of buildings expand as visible supports and mass contract.

Completed 1868 Labrouste's Reading Hall of French National Library proudly showcases new materials like metal columns and vaulting. Labrouste is first to design monumental public building flaunting its cast-iron structure. Slender columns support fan vaults and skylight, porcelain domes without Classical overlay.

Manifest Destiny: Westward, Ho!

American settlers push Westward, driven to colonize the continent from the Atlantic to the Pacific, a migration they believe is divinely sanctioned. Painters echo this patriotic bent by presenting the wilderness as a symbol of America's uncorrupted character and limitless future. While European painters' narrative images focus on the Neoclassic past or Realist subjects, American artists portray radiant landscapes. A spirit of optimism finds form in epic scenes of a natural paradise, a fresh start for humanity.

1871 One of a minority of American landscapes that hint at dark clouds on the horizon, Heade's "Newburyport Marshes: Approaching Storm" opts for atmospheric drama. Instead of grandiose wilderness, Heade portrays more accessible marshy terrain, paints not actual tempest but tension of darkening skies and fitful rays of light as prelude to storm.

1870

1868 Bierstadt specializes in heroic views of rugged mountain scenery. Huge paintings inspire awe and fetch high prices. Bierstadt is artist-explorer, one of first whites to see Yosemite. His panoramic paintings of frontier, as in "Among the Sierra Nevada Mountains, California," influence formation of national parks. His ambition is to paint "all outdoors," but vast canvases contain minute details, like individual flower petals, visible through magnifying glass supplied to potential customers.

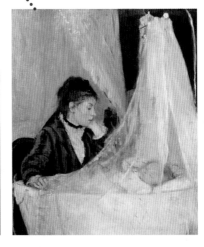

1872 In Morisot's intimate painting, "The Cradle," the artist's sister watches her sleeping child, draped in a veil of translucent gauze. The diaphanous white in background and foreground throws the maternal figure into high relief. Morisot's vigorous, loose brushstrokes—applied in free, direct style—enliven the canvas. Emphasis on the painted surface puts her squarely in the camp of modern painting.

c. 1874–76 Moreau, leading French Symbolist painter, displays exotic Romanticism in "The Apparition." Signature images are bizarre, evoke distant past and erotic subjects like *femme fatale.* Reacting against Realism, Symbolist artists like Redon and Moreau celebrate mysticism, the occult, and melancholy topics like disease and death. Color and line used to express emotion and ideas without factual description.

c. 1875 America's finest Realist painter, Eakins concentrates on the human figure, in motion or in thought. Many works spotlight athletes, as in "Sailing," but his portraits also feature brooding, solitary figures in shadow. Dedicated to accurate portrayal, he runs afoul of Victorian prudery, is fired for his teaching methods because of emphasis on the nude. Walt Whitman calls Eakins the only artist who can "resist the temptation to see what they think ought to be rather than what is."

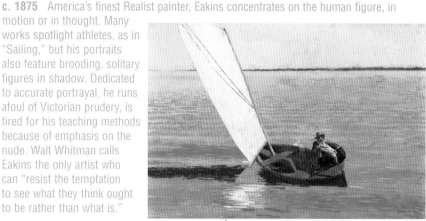

Cause Célèbre

When the well-known critic John Ruskin called Whistler's painting an atrocious disgrace, akin to "flinging a pot of paint in the public's face," the artist sues him for libel. All London follows the trial, as the artist defends his high fee for the painting, which Ruskin calls "slovenly." The price, Whistler asserts, reflects "the knowledge of a lifetime." He justifies its lack of identifiable objects, saying, "I have meant to divest the picture from any outside anecdotal sort of interest." Art should be free of morality or stories, "independent of all claptrap." When exhibited at the trial, the painting is displayed upside down. Whistler wins the suit but is financially ruined.

1875 Whistler proclaims form and emotion in paintings are similar to structure and "color notes" of music. He uses musical terms for titles, as in "Nocturne in Black and Gold: the Fire Wheel." Image of fireworks, which looks like rapid sketch, reflects his quest for innovative style, pared to essentials. While Symbolists explore inner world, Whistler's Aesthetic Movement ("Art for art's sake") filters perceptions of world through personal lens. Whistler refers to paintings as "arrangements," or decorative designs constructed almost abstractly.

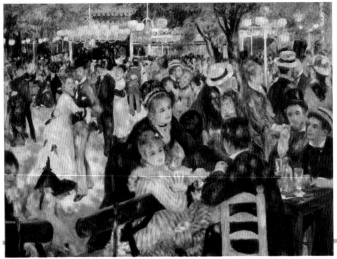

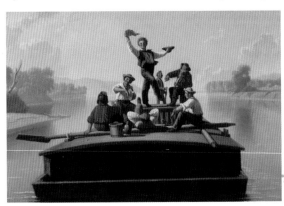

1877–78 Bingham's pyramidal composition of "The Jolly Flatboatmen" and luminist light on the Missouri River make this a masterpiece of genre painting. Dancers' carefree mood and unity of "primitive" boatmen idealize frontier experience for urban audience. Mostly self-taught, Bingham elevates common life to poetic status by casting it in ruddy, golden glow.

1876 One of most appealing paintings ever, Renoir's "Ball at the Moulin de la Galette" sums up Impressionist tactics. This painting of young folk carousing is a study of afternoon light sifting through acacia trees, creating fleeting effects of shadow and color. Painting outdoors, Renoir uses soft brushstrokes and bright tones to represent the gaiety of youth on a summer Sunday. He refuses to paint "the unpleasant things in the world."

Genre Painting

Genre paintings depict scenes from daily life, showing ordinary folk going about their domestic concerns, like husking corn, making hay, playing the fiddle, or cooking pies. As American society changes, becoming increasingly industrialized and urbanized, nostalgic views of rapidly vanishing ways of life are popular. They represent the democratic ideal, based on the purity and innocence of simple country people.

1877 Inness's late style of idyllic, spiritual paintings crowns him America's most beloved landscape painter. Influenced by intimate style of Barbizon School, he paints misty, expressive canvases drenched in soft light and green hues. With idealized naturalism, he eliminates detail in "Summer, Montclair" for overall effect of unity dominated by trees.

1877 Pissarro shows the Impressionist obsession with recording transient weather effects in "Trees and Flowers: Spring at Pontoise." Petals of flowering tree create scrim of white dots, extended in cottony clouds to unify composition. Short brushstrokes for white flowers contrast with green background for lively rhythm.

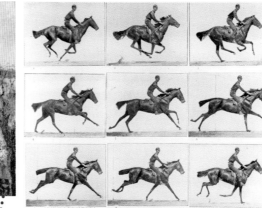

1877 Muybridge records sequential photos of a horse in "Transverse Gallop" to reveal previously unknown fact that all four hooves momentarily leave the ground at once. First to show figure in motion, Muybridge tours with projector and slides demonstrating actual movements of animals and models, a forerunner of motion-picture projector.

1877 Caillebotte's "Paris Street, Rainy Weather" freezes ephemeral moment in asymmetric composition. Influences include Japanese prints and photography; Caillebotte adopts the unusual angles, cropped figures, and flat colors of woodblock prints; and the spontaneity of snapshots. Caillebotte's street scene, portrayed in detached, objective style, records minutiae of modern life rather than lofty subject.

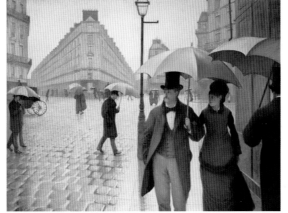

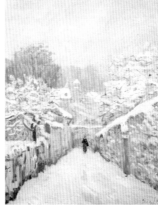

1878 Sisley employs subtle colors in limited palette, using flat, rapid brushstrokes and plunging path to animate landscape. He explores light effects on near-monochrome white and gray tints, achieving delicate harmony in "The Snow at Louveciennes."

Impressionism: A Whole New Way of Seeing

In 1874, French painters like Monet, Pissarro, and Degas mount a breakaway show in Paris to exhibit their works, which reject the established, artificial style of art. The common element uniting this diverse group (which includes Manet, Renoir, and Sisley) is their opposition to the prevailing history painting sanctioned by the Salon and to Romantic, emotion-infused art. They invent a new casual language to portray contemporary life, throwing off the throttling corset of strict rules of representation. Their works are carefully composed but have an effect of spontaneity. Their subjects are drawn from suburban and rural leisure activities as well as landscapes, often portrayed in colors so bright, they shock eyes used to the subdued haze of golden varnish embalming traditional pictures. They use short, broken brushstrokes to build forms and apply pure, unblended colors to capture an "impression" of the momentary effects of light on surfaces.

1880
Fantin-Latour's "Nasturtiums" illustrates floral still lifes for which artist is best known. His delicate, meticulous style counters loose brushwork pioneered by his friends Manet, Whistler, Monet, and Renoir.

1880–85
Reclusive American painter Ryder specializes in dreamy, imaginative subjects like "Moonlight," which suggests both his love of the sea and his haunted inner life. Aim: to express elusive mystery. Method: phosphorescent lighting, simplified forms, eerie evocation of nightmarish phantoms. Since he uses unconventional materials, surfaces of his paintings deteriorate badly.

Begun 1882 One of the most extravagantly original structures ever conceived, Spanish architect Gaudí's Church of La Sagrada Familia is based on concatenary curves (parabolic arches) for structural support. Style reflects Art Nouveau's embrace of natural forms ("Everything comes out of the great book of nature," Gaudí says), but he revs up organic curves to high art, like nothing seen before or since.

A Catalan Original

Antoni Gaudí's designs for buildings are as exuberant as the nationalist spirit of revival that animates his city of Barcelona and inspires artists to devise uniquely Catalan forms. Surfaces look like embroidery, covered with glass mosaics and brightly colored ceramic tiles. Serpentine walls undulate in and out like a dragon's spine, columns resemble bones, and iron grillwork explodes in eccentric, floral designs. His fluid lines and inventive sculptures transform chimney pots into mushrooms, pastry puffs, helmets, and conifers.

1882 Peto specializes in ultra-realistic still lifes that portray wall-hung objects. Trompe l'oeil renderings of woodgrain, photos, tacks, and letters are so exact, viewers routinely mistake them for the real thing. Carefully balanced compositions referred to as "deceptions."

1883 Roebling's Brooklyn Bridge is first wire suspension bridge and, at 1,596 feet long, world's longest to this date—more than twice previous record. A triumph of engineering at a heroic scale, it fuses new technology and materials with Old World style, adding 300-foot-tall granite towers with Gothic pointed arches for aesthetic flare.

1883–84 French Post-Impressionist painter Seurat develops new optical technique called Pointillism. "Bathers at Asnières" precedes his signature use of tiny dots of pure color. Idea is that viewer's eye mixes juxtaposed spots; theory attempts to combine science and art.

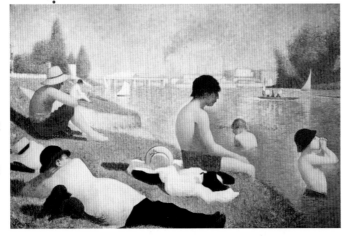

1886 Neoclassicism still lives with French sculptor Bartholdi's huge Statue of Liberty envisioned as Greek goddess. Inner metal armature is by engineer Eiffel.

c. 1888 Chase is tireless teacher and campaigner for American art. Paints iconic New York City scenes with fresh color in glossy style, then focuses on domestic subjects in idyllic mood to evoke exotic, fairy-tale world. Equally brilliant in oil or pastel, as in "Spring Flowers (Peonies)."

1887–89 Eiffel Tower, highest structure in world to this date, by Eiffel proves strength of 1000-foot-tall iron-and-steel skeleton. Marks entrance to 1889 Paris exhibition; considered "monstrous" when built, due to industrial design. To overcome public's fears about its perceived flimsiness, engineer Eiffel adds four massive grilled arches at base, which bear no load and are solely for illusion of sturdiness.

1889 Muck-raking police reporter Riis documents abysmal living conditions of poor in lower Manhattan in photo of "Slum in New York City." Using flash gunpowder to illuminate gloomy scenes, he reveals need for reform, inspires legislation regulating housing and child labor.

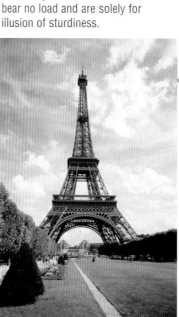

1886–91 Saint-Gaudens, leading American sculptor, establishes naturalism rather than Neoclassicism as preferred mode. Bronze allegorical statue called Adams Memorial is tribute to Henry Adams's wife who committed suicide. Veiled figure represents mystery of life, death, grief, and peace.

Post-Impressionism

Painters like Gauguin, Van Gogh, Seurat, Toulouse-Lautrec, and Cézanne invent new styles of painting not dependent on the effects of light, which characterized the work of their predecessors. Although their goals and methods differ, they push art in a more expressionistic direction veering toward abstraction. Purposely distorting forms or color, they shun naturalism. Cézanne, as one critic writes, is "the Christopher Columbus of a new continent of form."

1889 Van Gogh achieves his goal of a "star-spangled sky" in "The Starry Night." Moon burns like a fiery sun and stars seem to ignite and fizz. Quiet village anchors scene, with curves of hills exaggerated by tumultuous night sky, where clouds roll like waves. Soaring cypress tree and church spire link heaven and earth. Swirling brushstrokes and thick impasto suggest artist's gushing emotion. "Real artists," Van Gogh writes, "paint things not as they are, in a dry analytical way, but as they feel them."

1893–94 Philadelphia-born Beaux paints Grand-Manner portraits of wealthy subjects, emphasizing their affluence with elaborate dress and fancy knick-knacks. Impressionist brushwork and serene compositions soften her realism. Sitters look both poised and natural, as in "Young Woman with Cat."

1891 Nouveau-riche American capitalists commission extravagant summer "cottages" that rival French châteaux in size and magnificence.

Hunt delivers convincing Renaissance reproductions like Belcourt Castle in Newport, RI. Louis XIII-style manor has 60 rooms, with whole first floor devoted to 30 stables for horses.

1892 Gauguin purposely cultivates primitivism ("savage instinct") in paintings from Tahiti, like "Arearea, or Joyousness." "Here I enter into Truth, become one with nature," he writes. He simplifies forms and uses vivid, flat colors inside firm, rhythmic outlines to represent world of imagination. Instead of copying nature, he distorts form and color to create dream-like symbols. Art based not on perception of reality but artist's conception of it.

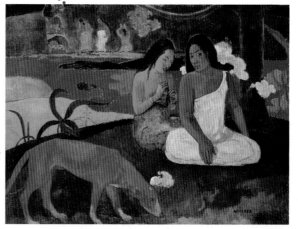

Art of the Poster

Thanks to innovations in lithographic printing, the 1890s–early 1900s are banner years for posters in Paris. Toulouse-Lautrec makes a populist art of the streets into a medium for fine art, using flat, rhythmic patterns, bold outlines, and vivacious lettering to grab the eye. Influenced by Kabuki theater prints, Toulouse-Lautrec condenses images into bold gestures to show the personality of an individual entertainer. The bell-shaped cape, hat at a jaunty angle, and flowing scarf of Aristide Bruant establish the popular singer's daring, dominant personality. "You cannot go anywhere," a columnist complains, "without finding yourself face to face with him."

1893 Denis, leader of Symbolist movement, proclaims key to modern painting: "Remember that a picture—before being a war horse or a nude woman or an anecdote—is essentially a flat surface covered with colors assembled in a certain order." "The Green Trees"— a decorative arrangement of flat forms and patterns in matte colors—makes no pretense of offering a window on reality.

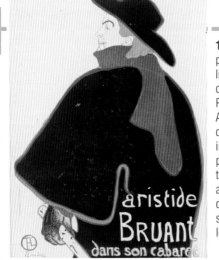

1893 Toulouse-Lautrec pioneers graphic art of lithographs with brilliant designs that advertise Parisian cabaret acts, like Aristide Bruant's. Images defined with strong lines, intense color, arresting pose, and form reduced to essentials. Lettering is an integral part of overall design. Establishes seamy, bohemian life as legitimate subject for art.

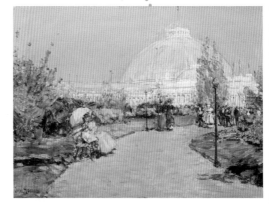

1893 Hassam pioneers American Impressionism, adopting rapid brush-work, vibrant color, "brilliant handling of light in "Horticulture Building, World's Columbian Exposition, Chicago." He's convinced "the man who will go down to posterity is the man who paints his own time and the scenes of everyday life around him."

The Nabis and Symbolists: Subjectivity Is Supreme

French artists including Vuillard, Bonnard, and Denis, influenced by Gauguin's expressionistic color, rhythmic lines, and personal symbolism, pursue an experimental track in the 1890s. Called the Nabis ("prophets" in Hebrew), they espouse radical art with messianic fervor. An overlapping movement, Symbolism, similarly rebels against Realism. Its proponents, like Redon and Moreau, also declare color and line convey ideas and emotions, but their subjects are bizarre and mystical. For both, suggestion trumps literal description.

1894 Homer's favorite subject is the sea, painted with realistic verve and force, so one can virtually smell the brine and feel the slap of the waves. "High Cliff, Coast of Maine" illustrates craggy rocks and crashing surf receding on deep diagonal to suck eye into scene. "I paint it exactly as it appears," the practical Yankee, immune to foreign influence, asserts.

1893 Munch's "The Scream" distorts figure and setting to depict psychic anguish. Expressive use of color and directional brushstrokes represent the mind cracking. Activated currents of sky and aggressive thrust of jetty illustrate unbearable pressure on anguished figure. Munch rejects naturalism, vows to paint people who "breathed and had emotions, that suffered and loved." His unhappy childhood reflected in discordant art: "Illness, madness, and death were the black angels that kept watch over my cradle."

1894 Tanner's "The Thankful Poor" demonstrates mastery of naturalistic painting learned from mentor Eakins. Tanner, first important African-American painter, paints scene infused with piety, unified by ochre light.

1894 British illustrator Beardsley combines Art Nouveau's sinuous lines with Aesthetic movement amorality in "The Dancer's Reward" showing Salome receiving head of St. John the Baptist. Known for black-and-white ink drawings, Beardsley exemplifies morbid tinge of *fin-de-siècle* decadence.

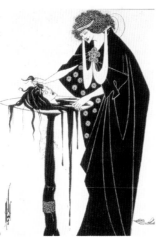

1895–97 Prendergast is one of first Modernist painters in America. Tapestry-like design, brilliant color of "Franklin Park, Boston" diverges from highly finished, stagnant style of official Academy. Packed compositions use whites for airy effect, convey cheery charm of elegant women and children ambling about. Adapts Impressionist techniques to watercolor.

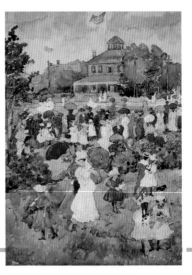

1895 After Seurat's early death, Signac becomes major proponent of Neo-Impressionism, or Pointillism. Professed aim: "to give color the greatest possible brilliance" through juxtaposing dots of pure, unmixed color. An avid yachtsman, he's best known for sublime sailing scenes with scintillating, mosaic-like surface. "St. Tropez, Thunderstorm" achieves new artistic freedom through clarity of method.

1895 Vallotton, who exhibits with the Nabis, paints "The Passersby, Street Scene" in abstracted style, simplifying form and using saturated blocks of color as in his coveted Japanese prints. With Gauguin and Munch, he revives interest in woodcut prints.

The Eight

Eight rebellious American painters (Lawson, Henri, Luks, Glackens, Sloan, Shinn, Prendergast, and Davies) mount their own exhibition in 1908 to protest the National Academy of Design's rejecting their work for an annual show. A crucial step toward modern art, the movement is christened The Eight. Work by these painters and colleagues like George Bellows is later dubbed the Ashcan School, for dealing with "sordid" subjects like realities of urban life. The shocking painting by Shinn that inspires this moniker portrays a beggar and cat scrounging in trashcans for food.

1897 Belgian Expressionist artist Ensor paints carnival revelers wearing grotesque masks and bizarre fantasy of death's head in "Masks and Death." Vivid colors heighten emotional impact of exaggerated features, which Ensor calls "scandalized, insolent, cruel, malicious" —perfect vehicles to evoke "exquisite turbulence."

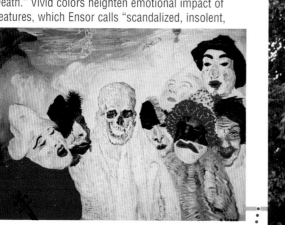

1897 Rodin rules in 19th-century sculpture, injecting passion and sense of movement into art to replace stale imitation of Classical forms. Rough-hewn head of author Balzac not so much a likeness as expression of "his intense labor, the difficulty of his life, of his incessant battles and of his great courage." Massive head seems to erupt from body in Rodin's image of creative genius. Outrage ensues. Contract for monument is cancelled; sculpture is compared to an owl, called "artistically insufficient," "a colossal fetus."

Sculpture Wakes Up

Rodin dismisses static, idealized Neoclassic sculpture based on ancient Greek models, saying, "They have stuffed the antique." He uses non-professional models like can-can dancers, who stroll around his studio assuming intensely energized poses. The body in motion becomes his means to evoke emotion, a revolution in sculpture that parallels Impressionism's fresh take on painting. Rodin, ridiculed for his daring, says he seeks "to render in sculpture what was not photographic. My principle is to imitate not only form but also life." His aesthetic principle is incompletion—the power of suggestion—suppressing detail and employing "unfinished" surfaces that simulate the pulse of life.

1897 Self-taught artist Rousseau is scorned by contemporaries, but Gauguin and later Cubists and Surrealists admire his naïveté and bizarre imagination. Rousseau intends "The Sleeping Gypsy" to be realistic genre painting in formal, Academic style. But its simplified forms and hyper-clarity, contrasted to incongruous details like absence of footprints in sand, give it air of dream.

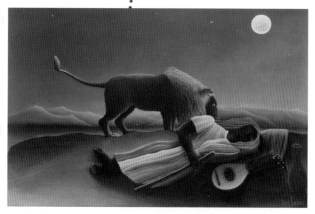

1897–98 Secession House designed by Olbrich showcases works by Vienna Secession artists who reject conservative art establishment. Bronze doors by the artist Klimt proclaim: "To the Age Its Art; to Art Its Freedom." Open metalwork dome is sphere of gilded leaves typical of Art Nouveau vegetal motifs. Olbrich adds new cubic rigor in rectangular framing wings.

Begun 1898 Horta's living room encapsulates curving, tendril-like lines of Art Nouveau style, which is centered in Brussels. Inspired by nature, he uses lines undulating like waves, flames, flowing hair, or vines. Whiplash wrought iron, wiry light fixtures, mosaics and tiles create new architectural vocabulary that rejects historical pastiche.

1898 Wagner demands new approach in architecture, declares independence from historical styles, pleads for functionalism. ("Nothing that is not practical can be beautiful.") Majolika House in Vienna is faced with colorful Art Nouveau ceramics forming a tree in blossom; reflects his early style before stripped-down, industrial designs.

1898 Daring composition with cropped figures in casual, ungainly poses characterizes Degas's signature dancers. He defines art as "the summing up of life in its essential gestures." He makes pastel medium his own, favoring matte surface and the freedom of drawing rapidly with color. Broken lines capture blur of moving figures. Degas not concerned with changing light; focuses on composition influenced by Japanese prints and photography, saying: "Even when working from nature, one has to compose. No art was ever less spontaneous than mine."

1899 Käsebier practices Pictorialist photography, which imitates Romantic paintings. She approaches medium as fine art, using carefully composed and lit tableaux and special effects in printing and developing. Subtlety and depth of "The Manger" highlight artifice and spirituality over naturalism.

1899 Crusading American realist Henri paints urban life forthrightly, portrays dingy scene,

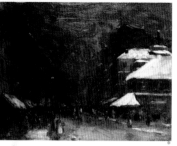

muddy skies in "Snow." Socially-aware genre paintings focus on teeming life of city slums, gritty subject that shocks viewers. Rapid brushwork lends aura of immediacy, as if captured by roving reporter.

c. 1899 Wooden figurative carving from Yoruba culture in Nigeria is part of ritual worship of god of thunder, Sango. Objects created for ceremonies are intended to be evocative more than descriptive, to generate and transform spiritual experience in both their maker and viewer. Yoruba people have a saying: "*Iwa l'ewa*," (character or essence is beauty). Their main aesthetic principle: object should express essential nature of subject. Religious art enhances sacred ceremonies, intensifies experience through its visual power.

Art Nouveau vs. Secession

When a shop called Art Nouveau opens in Paris selling decorative wares, it gives a name to an entire art movement. Asymmetrical, flowing, organic lines characterize Art Nouveau architecture, art, jewelry, glass, and furniture. An offshoot called Secession, also inspired by the English Arts and Crafts movement, veers in a different direction. In Vienna, Secession artists, designers, and architects as well as the Scottish architect Mackintosh, develop a more austere style of geometric simplicity.

Completed 1899 Most original thinker in his field, Sullivan is first modern architect, creates distinctive American style. His famous dictate "form ever follows function" rejects disguising functional frame of building with drape of historical ornament. Bayard Building unifies 13-story skyscraper with vertical accents. Soaring pilasters and unbroken mullions terminate in sculpted frieze and protruding cornice. Bountiful terra-cotta decoration enlivens surface.

c. 1899 Nearly five-foot-tall hornbill, or *calao* bird, carved by Ivory Coast Senufo tribe, represents a creation symbol, mythical bird that brought first seed to earth. Exaggerated, curved beak, widespread wings, and bulging abdomen suggest figure used in female initiation rite. *Calao* considered a protective spirit and fertility figure. Carving shows tendency to abstracted, rigid form with rhythmic, symmetrical lines.

The 20th Century: Storming the Barricades

As technology (the airplane, automobile, radio, telephone, elevator, and motion picture, to name just a few inventions) transformed life at the outset of the century, the pace of artistic innovation accelerated. The collapse of former social and economic paradigms led to widespread experimentation in all art forms. Composers like Schoenberg and Stravinsky, dancers like Isadora Duncan, poets like Rimbaud, Eliot, and Pound, and writers like James Joyce pioneered radical concepts of collage and abstraction in art. They revamped form, harmony, and conventional narrative, forging a revolution in creative expression.

In popular culture, the Charleston, Lindy, frenetic jazz and bebop replaced the stately quadrilles of the Gilded Age. Even genteel ladies hacked off their elaborate coiffures and pitched their gloves. Skirt lengths rose to dizzying heights as Victorian propriety went down to dusty defeat.

Leading the charge were visual artists, as styles mutated in hyperkinetic succession. In painting, Paris continued as the undisputed leader of the avant-garde. The forefront was more scattered in architecture. Germany's Bauhaus spawned the International Style of austere, functional "machines for living" (in Le Corbusier's words), and American skyscrapers provided the template for further developments. In sculpture, artists built on Rodin's legacy with new spatial explorations.

Everything seemed possible. Total freedom to explore any direction was the goal. Innovators pursued divergent paths: Cubists followed Cézanne and Seurat's obsession with structure, while Fauves developed van Gogh and Gauguin's focus on emotion. Although both camps were revolutionary, their means differed. The Cubists dissected form; Fauves distorted color. The Fauves (meaning "wild beasts," a slam on their audacity) truly let the beasts out of the cage in 1905. Renaissance rules of perspective became obsolete. More and more, artists represented their own take on reality, rather than accepting the time-worn job (commandeered by the camera) of imitating appearance.

In Italy, Futurists celebrated speed, as Russian Constructivists reduced the world to geometry. A post-World-War-I recoil against traditional values galvanized a wholesale rejection of art conventions. German Expressionists combined slashed forms and clashing colors, Mondrian sought equilibrium with his linear grids of paint, and Kandinsky broke through into pure abstraction.

Change rocketed along, linked by a common propulsive thread: as poet William Carlos Williams put it, to "make it new." In an attempt to express the tempo and spirit of the 20th century, these artists, called Modernists, took different approaches. Some, like Bauhaus artists and architects, were inspired by utopian aims, believing enlightened design could achieve social progress. Others, like the absurdists of Dada and Surrealism, despaired of finding any rational meaning and focused on dreams and fantasies.

After World War II, the scene shifted from the Old World to the New. Painters called Abstract Expressionists seized artistic leadership in New York. "New meanings require new techniques," Jackson Pollock announced. Pollock not only "broke the ice," as Willem de Kooning put it, he broke any remaining rules, throwing out paintbrushes, recognizable imagery, and any distinction between foreground and background.

Reacting against the Abstract Expressionists' dissolution of images, the

next generation of artists painted in realistic detail the most transgressive, "Pop" images they could conceive—cartoon illustrations and advertising emblems, the opposite of "High Art." Then another generation rebelled against that trend. Minimalists took to heart Mies van der Rohe's doctrine of "Less is more" and adapted the Bauhaus style to sleek, machined sculptures, absent the hand of the artist. Conceptual art then dematerialized the art object altogether, claiming an idea alone, rather than a physical product, constitutes a work of art.

With all taboos defunct and complete permission to experiment granted, what's left to dare?

"Give us this day our daily dread," poet Lawrence Ferlinghetti expresses the loss of faith in our post-modern world. Everything's now up for grabs as the pendulum swings from one extreme to its opposite. Art can be a multimedia performance or an installation of disparate objects creating room-sized tableaux. Contemporary art is increasingly based on new electronic media, photo-derived, created on video, or exists in the virtual or cyber world. And then a reaction to such mechanical means occurs, as painting and drawing return with a bang.

Although styles rapidly come and go, two skeins consistently interweave in 20th-century art: subjects drawn from the rational, external world or from the artist's internal being. The former is analytic and realistic, the other imaginative and irrational. In a global, multi-cultural arena, identity politics absorbs the artist, no matter what the means of expression, as prior values and techniques continue to be questioned.

Ben Jonson said Shakespeare "holds a mirror up to nature." But modern artists reflect the kaleidoscope of human nature. "What are you? What am I?" the German painter Max Beckmann asked. "Those are the questions that constantly persecute and torment me."

"We are all worms," Winston Churchill said, adding, "but I do believe that I am a glow worm." Artists seek to cast light on the conundrums of life, to clarify human aims by organizing daily chaos into expressive forms. It's no wonder the works are as varied as our world. Reflecting the confusion and dynamism of modern life, this frenzy of constant changes in art expresses a world in flux. Artists try to digest, arrest, or merely capture our restless reality, as it constantly flows out of reach, elusive as quicksilver.

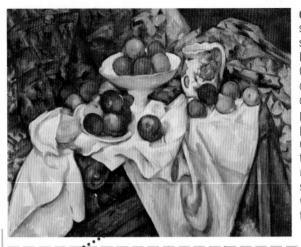

c. 1900 Visual structure reigns supreme in "Still Life with Apples and Oranges," as Cézanne creates pyramidal composition from patchwork of "color planes" applied in direction of surfaces they evoke. Warm, red-orange hues seem to advance, while cool, blue-green tones recede.

Viennese Avant-Garde

Gustav Klimt founds the Vienna Secession. He advocates populist art that's meaningful for all, free from the conservative ideas of the past and from the stuffiness of the Austrian court. Painter Kolomon Moser and architect Josef Hoffmann subscribe to the Secession's ideals. Together they found a crafts workshop called the Wiener Werkstätte. Its premise is that furniture, cutlery, jewelry, and glassware should incorporate the same high standards of design and workmanship as painting and sculpture. They formulate the idea of *Gesamtkunstwerk* (a total work of art), in which decorative arts and architecture form an organic whole, elevating applied arts to the level of fine art.

1900

1900 Guimard designs ironwork Art Nouveau arch as entrance to Paris Metro, combines florid shapes and colorful, glazed earthenware tiles. Glass canopy looks like dragonfly wings, green-painted supports like stalks. Flamboyant design shocks Parisians accustomed to Beaux-Arts Classicism.

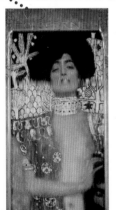

1901 Klimt's paintings are often allegorical, mysterious, charged with eroticism. "Judith with Head of Holofernes" is dazzling display of his signature elements: enamel-like gold, bright mosaic of colors, exotic subjects, and rich, decorative patterns. Figure placed against intense, tapestry-like background that frames delicate face.

1901 Scottish architect Mackintosh's design for house of art-loving friend, shown in engraving, incorporates Art Nouveau forms in interior design and furniture. Stylized rosebud motif in pink, mauve, and pale green is stenciled on white enameled woodwork and elongated furniture to create delicate, light-filled spaces.

1901 Rodin calls Sargent "the Van Dyck of our times," a tribute to the American painter's bravura portraits of the gentry and *nouveau riche*. As painter for glitzy, international clients like "Ena and Betty, Daughters of Asher and Mrs. Wertheimer," Sargent creates sumptuous portrayals of elegant world, enlivened by his sensual handling of paint and virtuoso technique in representing texture.

c. 1902 American painter and printmaker Cassatt exhibits with Impressionists in France. When she sees Degas's pastels in gallery window, she says she would "flatten my nose against the window and absorb all I could of his art. It changed my life." Maternity is her signature subject, but her modern Madonnas are touchingly human. Degas's influence clear in sage background, contrasting complementary colors, and sitter's pose, oblivious to viewer, in this "Mother and Child" pastel.

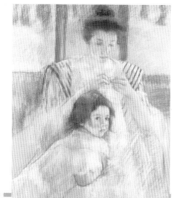

1902–04 Cézanne paints "Mont Sainte-Victoire" obsessively. Determined "to make of impressionism something solid and enduring, like the art of the museums," he uses measured brushstrokes to build mass and highlight underlying geometric shapes. Aim: to correct Impressionism's emphasis on transitory light and color through disciplined painting style.

1902–05 In bronze "The Mediterranean," French sculptor Maillol simplifies shapes to reveal formal structure in weighty female nude. Poses figures in solemn, tranquil attitudes with minimal gestures. Strips architectural frame and anecdotal references from sculpture, focusing on pure form.

New Forms for a New Age

The hub of avant-garde architecture is Chicago, where architects like Root and Sullivan reject the custom of hiding a building's understructure behind a historical façade. New building types, like the first skyscrapers, require a new vocabulary of expression, like vertical piers, large expanses of glass, and geometric or Art Nouveau ornament. The simplicity of a building's underlying grid structure is expressed in the increased proportion of glass to solid masonry, foreshadowing future curtain-wall high-rises in which the inner steel frame, not the exterior walls, carries the load.

1904 For Redon, "True art is art that is felt." His "Dream" displays mysterious ambiguity of Symbolist movement. Uses colors as symbolic language to evoke

emotion, express what words cannot. "My originality consists," he claims, of putting "the logic of the visible at the service of the invisible." Known for radiant floral still lifes and pastels, he claims, "With pastel, I have recovered the hope of giving my dreams greater plasticity."

1906 Derain applies primary colors in dots and dashes of paint that explode, he says, like "charges of dynamite." In "Big Ben," he pioneers bursts of strong color

used for expressive force, independent of descriptive function. He eliminates lines, but varying his brushstrokes from choppy to flowing creates sense of movement.

A group including Matisse, Vlaminck, and Derain exhibit together in 1905, showing paintings so stridently colored, a critic dubs the artists wild beasts, or *fauves*. Embracing their outlaw status, Matisse proclaims, "Fauvism isn't everything, only the beginning of everything." As the first major avant-garde movement in 20th century art, it changes how artists depict the world. When the painters liberate color from its descriptive role, unleashing its power to express emotion, critics consider their experiment "raving madness." By 1908 Fauvism burns out, for, as Braque says, "You can't remain forever in a state of paroxysm."

1905–11 Hoffmann's Palais Stoclet in Brussels is outstanding example of concept of Gesamtkunstwerk (total work of art). A master piece of interior and exterior harmony and refinement, its walls of white marble are bordered in gilt metal for rectilinear effect. Interior gleams with marble, mosaics, glass, gold, teak, and onyx. Hoffman designs all furnishings, manufactured to highest standard.

c. 1905 Vlaminck's "Restaurant de la Machine at Bougival" exemplifies Fauve style of vivid, non-representational color, with red and blue tree trunks and green sky painted in purposely crude style. Incendiary canvases prompt a critic to complain Vlaminck paints "as other men throw bombs." Makes breakthrough after viewing revelatory Van Gogh exhibition; he squeezes paint directly on canvas, smears clashing colors with palette knife. Exuberant landscapes almost vibrate.

c. 1906–07 Modersohn-Becker, before dying at age 31, develops personal form of Post-Impressionism, displaying primitive force of what she calls "the great simplicity of form that is the wonder."
In "Mother and Child," she paints maternal figure as heroic life-giver, earthy, assertive, and monumental, holding images of fertility. Struggling to be seen in an art world hostile to female artists, she writes, "I know that I shall not live very long. . . . And if I can paint three good pictures, then I shall go gladly, with flowers in my hair."

1907 Loos revolts against frills of Vienna Secession in manifesto proclaiming, "Ornament is crime." Campaigns for simplicity and functionality, ushering in plainer style while retaining beautiful materials, elegant details. The American Bar (or Kärtner Bar) in Vienna is squared-off jewelbox of brass, marble, mirrors.
Loos's innovation: flowing, continuous spaces, rather than floors cut up into small rooms without flexibility.

Picasso, Mr. Modernism

The chameleon-like Spanish artist Picasso (1881–1973) morphs from one style to another in a career that spans seven decades. Relentlessly questing for new forms of expression, he, along with his colleague, the French painter Braque, invents Cubism in about 1907, breaking away from the idea of art as an imitation of nature. This new form of realism, intent on an intellectual analysis of appearances, shows subjects deconstructed into multiple facets, as if many sides are viewed simultaneously. "I paint what I know," Picasso says, "not what I see." Never content to repeat himself, Picasso follows his muse through a succession of reinventions, always in the forefront of radical experimentation.

1907 Picasso's "Les Desmoiselles d'Avignon" is pivotal painting in modern art, banishing any remnants of 19th century tradition and ushering in a mixed-bag style of painting dependent on an artist's private conceptions rather than visual perceptions. Picasso distorts the prostitutes' faces, giving them grotesque features like African masks. He crowds the figures together in a space sliced by jutting angles to produce an impression of fear, violence, and tension.

1907 Sloan's "Throbbing Fountain, Madison Square" exemplifies dynamism of urban life. A former newspaper illustrator, Sloan uses rough brushwork to show sympathy for common man and passion for social justice; portrays warm humanity, life of streets. A champion of lower classes, he runs for state assembly in 1908 as socialist, is defeated, but continues his mission as artistic chronicler of vibrant city.

1909 Matisse uses limited colors in "The Dance"—green, blue, flesh tones, and black—and flattens the figures' bodies to make minimal lines deliver maximum impact. Abstracted bodies in front and rear are same size, eliminating illusion of receding distance. A master of sinuously curving lines and expressive color, he asserts, "Color was not given to us in order that we should imitate Nature, but so that we can express our own emotions." His desired emotion is pleasure: "What I dream of is an art of balance, of purity and serenity devoid of troubling or depressing subject matter."

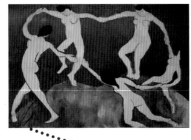

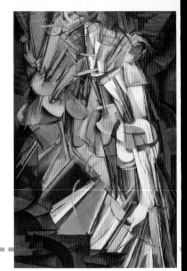

1911 Chagall's "I and the Village" crams emblems of Russian village life in superimposed, fragmented style influenced by Cubism. Memory picture of Jewish peasant life implies equal footing of animals and human beings, united in circle bisected by diagonals.

Armory Show

A 1913 exhibition of avant-garde European art held in New York's Armory excites a hostile reaction. Works by Picasso, Cezanne, Brancusi, and Matisse outrage viewers accustomed to tame, representational art, inspiring crowds to burn them in effigy. Duchamp's "Nude Descending a Staircase" elicits the most bitter response. One journalist terms it an "explosion in a shingle factory." The artists are called "lunatics, depravers," an affront to civic morality. Ridicule aside, the show introduces American artists to progressive art, overcoming their provincial conservatism.

1912–13 Braque invents a new medium, *papier collé* (pasted paper) or collage. In "Still Life with the word 'VIN'," cubistic curves allude to shape of wine (*vin*) bottle. His snippets of paper glued on the canvas, combined with drawing in charcoal, ink, and watercolor, produce a cut-and-paste innovation, rapidly taken up by his friend Picasso. Braque enriches texture by mixing sand in pigment and adding glued-on bits of newsprint or wallpaper.

1912 Duchamp rebels against merely "retinal" art, determined to engender ideas and "put painting once again at the service of the mind" rather than turning out "visual products." His "Nude Descending a Staircase" causes a sensation when he tries to render "a static representation of movement." He later invents the "readymade," an ordinary object like a urinal elevated to the category of art solely by the artist's designating it sculpture. A seminal figure in art movements like Dada, Surrealism, and later Conceptual Art, Duchamp produces few works but has powerful impact, pushing art toward becoming an intellectual, dematerialized concept.

1912 Schiele takes demand for truth in art to extreme in "Self-Portrait with Bent Head." Influenced by Freud's theories of buried psychic pain, Schiele portrays his tormented fantasies and fears through agonized expressions, bruised, translucent skin that reveals blood throbbing below surface. Agitated figures often depicted in void, limbs and fingers elongated and knobby. Known for sexual themes and dark, emotionally charged existentialism, he dies at age 28.

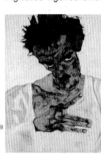

1913 Kirchner's "Street, Berlin" exemplifies urban malaise. According to the German painter, "I was always alone, for the more I mixed with people the more I felt my loneliness." Although

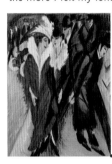

street bustles with people, acidic colors and sharp angles in densely constricted space create tension. Kirchner's aim: to give visual form to modern life.

Futurism

The poet Marinetti, called "the caffeine of Europe" for the jolt he provides to rudely awaken the slumbering art world, issues the Futurist manifesto, calling for "courage, audacity, and revolt." An Italian movement celebrating, as Marinetti says, "the beauty of speed," Futurism aims to destroy institutional symbols like libraries, academies, and museums. Italian artists like Boccioni, Balla, Carrà, Russolo, and Severini praise the industrial age during the first decade of the 20th century. They employ Cubist fractured forms and "lines of force" to achieve a multiple-exposure effect denoting propulsion. Their favorite word is "dynamism," and they adore progress, but the movement comes to a halt when Boccioni dies in a riding accident in 1916.

1912 Trained as a woodcarver, German Expressionist Nolde shows forceful, "primitive" style in his "Head of a Woman" woodcut. In paintings, he uses harsh color, simplified forms, and crude distortions. Woodcut conveys emotional intensity through vertical gouges, sharp black/white contrast.

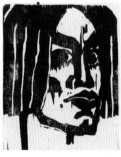

1913 Boccioni's "Unique Forms of Continuity in Space" reinterprets well-known Greek sculpture "Winged Victory," showing charging figure with flame-like flaps to suggest

advancing stages of movement. Currents of air rushing past extend beyond figure, merging space and solid sculpture. Speed, Boccioni says, is "the new absolute." By portraying velocity, he hopes to "achieve a complete revival of this mummified art" of sculpture.

1914 Kokoschka's "Bride of the Wind" depicts the painter and his lover Alma, a *femme fatale* married successively to the composer Mahler, the poet Werfel, and architect Gropius. Kokoschka's cathartic painting makes tension

visible in agitated brushwork and wiry lines scratched into paint. He thins oil paint to make skin look translucent as if flayed, wants to bring subjects alive through "effect of an inner light." Archetypal work of Austrian Expressionism.

c. 1914 "The Enigma of Departure" illustrates De Chirico's metaphysical style. Mysterious shadows of a statue and unseen human figure stretch across vacant piazza, as dark arcades lead menacingly toward red tower. Illogical perspective, sinister shadows, and empty space create enigmatic, unsettling atmosphere. De Chirico, hailed as forerunner of Surrealism, wins exemption from military service by using paintings as evidence of mental instability.

1915 Malevich pioneers geometric abstraction in "8 Red Rectangles." He simplifies motifs into pure shapes to make painting independent of external world, capable of conveying spirituality. "It is absurd to force our age into the old forms of a bygone age." Later, he famously paints a white square on a white background. Also black on black, and red on red.

1915

1915–19 Atget renders everyday objects mysterious in haunting photographs of Paris. Clean, uncluttered style of "St. Cloud" makes fountain into object of magical stillness and possibility. Arresting scenes focus on essentials, viewed with hyper-clarity but evoking the unsaid and unseen.

Expressionism

"My goal was always to express emotion and experience with large and simple forms and clear colors," Kirchner says, summing up Expressionism. The style, practiced by two groups of artists called *Die Brücke* (The Bridge) and *Der Blaue Reiter* (The Blue Rider), dominates German art from 1905-30. It includes painters like Kirchner, Kandinsky, Klee, Münter, and Marc, who combine bold Fauve colors with distorted figures. The common element is rejecting an imitation of nature, in order to follow emotion.

c. 1915 Nadelman, pioneer of modern American sculpture, simplifies form to rhythmic curves in "Man in the Open Air." Combination of nude with dandy-ish bowler hat and floppy tie outrages viewers who expect fine art to be devoid of such playful touches.

1915 Kandinsky invents abstraction, frees painting from references to reality. "Composition" contains no recognizable object, is "a graphic representation of a mood." Painter wants art to speak directly to viewer through language of line, color, and shape.

Birth of Abstraction

In 1910 Kandinsky returns to his studio in Murnau (near Munich) at twilight, and painting is never the same again. "I was suddenly confronted by a picture of indescribable and incandescent loveliness," he recalls. He stares at the painting, which "lacked all subject, depicted no identifiable object," until finally he recognizes "it for what it was—my own painting, standing on its side on the easel." The revelation that color evokes emotion independent of subject spurs Kandinsky to discard any semblance of realism and embark on a path of "non-objective" painting.

1917 Modigliani modernizes classic subject of "Reclining Nude" by elongating torso, exaggerating bulging thighs, and cutting off model's body at edge of canvas. Concentrates on portrayals of female, typically with giraffe-like neck, sinuous curves, and simplified form. Police order gallery show of his nudes closed, confiscate paintings as pornography.

c. 1915–20 Popova's "Composition" combines overlapping planes in tension—tilted, intersecting, and slicing through each other to suggest dynamism. Popova claims reality must be deformed and transformed into geometric abstraction to be subject of painting, calls her work "painterly architectonics." Key member of Russian avant-garde, in 1921 she rejects easel painting as bourgeois, commits to industrial design of clothing, fabrics, ceramics, and set design for theater.

1917 Lithograph of Bellows's famous painting "A Stag at Sharkey's" shows his favorite subject: raw physicality. Bellows specializes in pulsating life of city's piers, bars, and sporting venues, shown in all their turbulence and vitality. A semi-pro baseball player, he paints straining bodies to portray strength and heroic energy of working class.

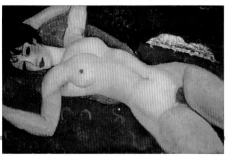

1917 O'Keeffe's "Evening Star III" water-color reflects simplified Modernist style. O'Keeffe focuses on landscapes, flowers, and bones, in semi-abstract, reductivist manner, fusing subjective emotion with pure forms. Stylized, precise composition relies on curves and bands of color for effect.

The Russian Revolution

For about 15 years, a revolution in Russian art coincides with profound social and economic upheaval in the Soviet Union. "Long live the art of the Proletarian Revolution!" Bolsheviks proclaim, expressing artists' hope to convert a feudal society into a workers' paradise. Considering art a vehicle for emancipation and education of the illiterate public, or "a living factory of the human spirit," as the poet Mayakovsky says, artists turn out models for monuments, paintings, and sculpture as blueprints for the coming utopia. Abstract art movements called Constructivism and Suprematism enlist idealistic artists like Malevich, Tatlin, Popova, Goncharova, and Rodchenko, who devise utilitarian objects, functional art for the masses. By 1924, Stalin suppresses these "proletarians of the paintbrush."

1916–19 Monet persists in Impressionist style, portrays garden at Giverny in "Blue Water Lilies." During last 30 years of his life, water garden is his passion. He paints series of pond and water lilies under differing conditions of light and weather. Although his goal is to capture exact reality of scene, paintings seem ever more abstract and diaphanous.

1919 Beckmann's "Night" is harrowing portrait of torture, derives from horrors witnessed by artist during four years in the trenches of World War I. Artist paints human cruelty in meticulous detail, a scathing indictment of nationalism. Angularity reinforces image of disfigurement and pain. Beckmann shines raking light on suffering, distorts figures into grotesques to illuminate brutality of war.

1919 Tatlin creates model for Monument to the 3rd International, intended as 1300-foot-tall tower for center of Moscow. Celebrating Bolshevik victory, tower embodies continual progress through spiral shape. Central glass cylinder would revolve at three different speeds. Building is never constructed, due to lack of raw materials (glass, iron, steel).

1920 Schwitters scavenges scraps of paper from streets, gutters, and trashbins for collages like the "Front Cover from *Die Kathedrale*." Says he can't see why old tickets, wires, and rubbish "should not be as suitable a material for painting as the paints made in factories." Calls these collages "*Merz*," from the second syllable of *Kommerz* (commerce). "*Merz* stands for freedom from all fetters," he insists, adding: freedom is "the product of strict artistic discipline." Rectangles and lettering form coherent whole.

1922 Klee uses childlike images and rainbow-bright colors in "Senecio." Morphs from early, wiry drawings to geometric grids of Bauhaus period, but whimsical inventiveness is constant. "Truth demands that all elements be present at once," he writes. Art straddles representational and abstract styles, organic and geometric, spontaneous and purposeful. "Art does not reproduce the visible; it makes visible."

1924 Ernst's "Two Children Are Threatened by a Nightingale" combines Dada absurdity of title with unfathomable imagery and suggestions of a disturbing narrative. Ambiguous title important to push viewer from rational realm into glimpse of the absurd. Conveys vulnerability, dislocation, anxiety. Ernst says imagery may stem from his grief when a pet cockatoo died during his childhood. For years, he suffered from "a dangerous confusion between birds and humans."

1921 For Marin, everything's alive. He wants "what appears on the paper [to] have a life of its own." Great American watercolorist paints sea, sky, mountains in distinctive, semi-abstract style. Forbids viewer to look for message in painting; says when you look at a daisy, "you just look at that bully little flower. Isn't that enough!" Warring forces in "The Sea, Maine" push and pull scene into broken shapes. Planes and angles suggest heaving ocean. He leaves canvas partially bare for airy feel, shows "great forces at work, great movements." Compares his work to golf: the fewer strokes, the better.

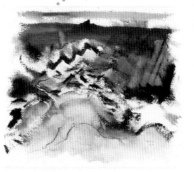

Dada

Reacting to the absurdity of war, refugee artists in Zurich use a nonsense word to describe their movement, founded in 1916. For the next seven years, they use art to undermine authority and criticize the lunacy of wholesale slaughter. Embracing irrationality, artists in Europe and the U.S. denounce convention, aiming to shock their audience into original thinking. Since reason has failed civilization, they cultivate intuition, imagination, chance, and illogic. When Schwitters is asked, "What is art?" he replies, "What isn't?" Dadaists include Arp, Duchamp, Man Ray, Schwitters, the ceramist Beatrice Wood, and the poet Tristan Tzara.

1924 In "Le Violon d'Ingres," Man Ray alters a photograph with ink to transform a nude into a violin and—as the French title (an idiom for one's personal passion) implies—a symbol of obsession. Poet Breton praises ingenuity and novelty of images, calls Man Ray "the catcher of the unseen." A sidekick of Duchamp, he makes art not for the eye, but the mind.

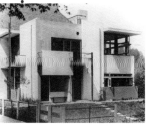

1925 In "The Window," Bonnard takes to heart Renoir's advice, "Make everything more beautiful." Depicts idyllic scene in delicate, muted colors that harmonize without discord. Paintings, imbued with luminous warmth and decorative pattern, provide intimate views of domestic interiors and gardens.

1924 Kollwitz's "Never again war" poster is forceful protest against oppressors; reflects her strong social conscience. A mother who lost her son in World War I and grandson in World War II, Kollwitz dedicates her art to the poor and downtrodden. Depicts death and injustice in graphic art of few lines, but suffused with power and compassion.

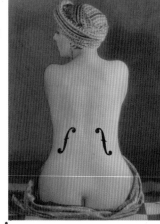

1924 In Schroeder House, Dutch architect Rietveld reflects abstract, geometric style of Mondrian's art and movement known as *De Stijl* ("the style"). Cubic shapes, cantilevered balconies and roof, and asymmetrical composition create a floating effect, one of first examples of International Style of modern architecture. Primary colors of yellow, red, blue accentuate white masses.

1925

Surrealism: The Mind's Eye

Appalled by the ten million killed or maimed in World War I and a victory, as Churchill says, "bought so dear as to be almost indistinguishable from defeat," artists reject all conventions—aesthetic, social, and moral. In the 1920s and '90s, art turns even more internal, drawing on Freud's theories of the unconscious. Surrealist artists like Ernst, Dalí, Duchamp, Matta, Magritte, and Giacometti, urged on by the poet Breton, attempt, as Jean Arp puts it, "to dream with [their] eyes open." Artists cultivate irrationality, chance, and paradox to portray their fears and fantasies. Two strains: objects painted realistically but set in strange combinations and context, and improvised doodles and techniques to eliminate conscious control, producing bizarre imagery.

c. 1927 Brancusi's "Bird in Space" represents not a bird but an aerodynamic concept of flight. "What is real is not the external form, but the essence of things," the Rumanian sculptor insists. Brancusi draws themes from nature, reduces them to most elemental form. When he tries to bring "Bird" to U.S., customs inspector refuses to deem it sculpture, insists it be taxed as raw metal.

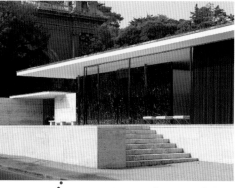

1929 Mies van der Rohe makes sublime architecture out of "almost nothing" in Barcelona Pavilion, demonstrates truth of his famous adage "Less is more." He pares away materials and support to most refined, minimal elements. Result is flowing, airy space: tiny in size but seemingly expansive, since it blends inside and outside in seamless harmony. Mies, foremost practitioner of Bauhaus International Style, creates pure form out of elegant materials like marble, glass, and polished wood, proving "God is in the details."

1928 In "The False Mirror," Magritte adopts Surrealist technique of placing objects painted with meticulous realism in bizarre juxtaposition. Eye and sky offer no surprises until he merges—and dislocates—them. Pupil becomes dark sun and iris, blue sky. Seeing banal objects in strange context provides mental jolt.

A Balancing Act

Piet Mondrian invents a geometric style of utmost simplicity, which he calls "Neo-Plasticism," also known as *De Stijl* ("the style") in Dutch. Saying, "Nature is a damned wretched affair," Mondrian removes all traces of pictorial reality. He arranges rectangles and primary colors asymmetrically. Intersecting vertical lines represent vitality, while horizontal lines symbolize tranquility. This balance of opposites creates a precise order and equilibrium lacking in the chaotic natural world.

1930 Sheeler's "American Landscape" is based on photo of Ford's River Rouge auto manufacturing plant. Sharp outlines, clean surfaces are even more exact than photograph, while extraneous details are eliminated. Firm composition of verticals balanced by horizontal and diagonal lines produces effect of clarity, stasis. Painting is compromise between abstract and representational art.

1931 Most famous Surrealist work, "Persistence of Memory" represents what Dalí calls "hand-painted dream photographs." Through precise technique, achieves his "ambition . . . to materialize the images of concrete irrationality." Uses conventional depth and perspective to make unreal things like floppy watch and blobby creature seem real. Dalí induces psychotic hallucinations to generate imagery from subconscious and "discredit completely the world of reality."

Bauhaus

Germany gives birth to the International Style, which defines modern architecture—a stripped-down aesthetic that eliminates frills to reflect the Machine Age. The Bauhaus, a state school uniting fine and applied arts, advocates simple, mass-produced structures intended to promote an egalitarian society. A "new architecture" and a new society would spring from the drafting board, bringing both social and aesthetic reform. From the 1920s–70s, characteristic structures for wealthy individuals, corporate clients, and humble dwellings for ordinary citizens boast common traits: open interiors, unadorned, white walls; strip windows, flat roofs, and concrete, glass, and steel construction.

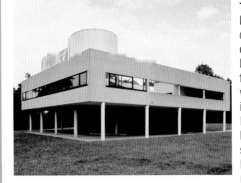

1929–31 Swiss architect Le Corbusier believes enlightened design exerts positive influence on human nature: humanity will be rational, orderly, efficient, and functional if housed in a building with these virtues. Motto: house is "a machine for living in." In Villa Savoye, he combines his three essential elements—sunlight, space, and greenery. Flat roof, ribbon windows, unadorned surfaces, cubic shape comprise machine aesthetic.

1931 Rivera, member of the Mexican muralist triumvirate including Orozco and Siqueiros, illustrates tragic moment from Mexican Revolution in "Liberation of the Peon." Simplifying figures' forms to imply monumental dignity, he glorifies the *campesinos* who fought dictatorship. Showing them united as they shroud body of murdered comrade, the peasants enact updated version of classic theme, Christ's descent from the cross. Rivera, revealing sympathy for indigenous people and the masses, suggests only death releases the oppressed from pain.

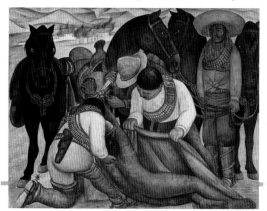

1933–34 Miró paints flying birds at top of "Hirondelle/Amour," with black line looping from swallow to its name, *hirondelle*. Joyous shapes and colors bounce in carefree levitation, as if in flight. Miró combines recognizable motifs derived from fact with bestiary of amorphous squiggles from realm of imagination. Says, "We Catalans believe you must always plant your feet firmly on the ground if you want to be able to jump up in the air." Innovates new pictorial space—without modeling and eliminating figure/background contrast, perspective, shading. "The simpler the alphabet, the easier it is to read."

Precisionism

In the 1920s, American artists like Sheeler, Demuth, and O'Keeffe determine to bring the U.S. out of the cultural backwater and into the modernist mainstream. Glorifying industry, which they identify with progress, they paint boats, bridges, skyscrapers, farm and factory buildings. The paintings achieve a semi-abstract effect through flat areas of color, applied with a smooth, precise technique, highlighting simple, geometric forms. The Precision-ists elevate the urban and industrial landscape, shown in cold, brilliant light, to epic stature.

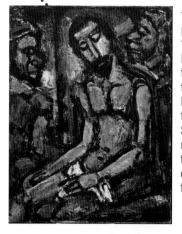

1932 Deeply devout, Rouault paints episode from Bible in "Christ Mocked by Soldiers." Heavy lines owe debt to his training as stained-glass apprentice. Applies paint thickly, allowing layers of underpainting to show through and enrich surface. Soldiers' faces are grotesque masks of ignorance, contrasted to Christ's serene countenance, emblem of acceptance and forgiveness.

1936 Hired by the Federal Art Project of the New Deal, Abbott spends three years hauling 60 pounds of equipment through city streets to suggest the flux of the metropolis and to show "the past jostling the present." With expressive technique, she points camera upward, using crisp focus to capture "Manhattan Bridge." Radically cropped, foreshortened view exaggerates vertical thrust.

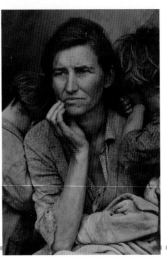

1938 Gropius designs his Massachusetts home in Bauhaus factory style, with flat roof, glass blocks, ribbon windows, chrome banisters. Uses machine-age palette of black, white, gray and mass-produced fixtures. His lecture, "Art and Technology—a New Unity," sets tone for International Style that becomes paradigm for modern buildings for next 50 years. Gropius justifies minimalist style as rejection of bourgeois historical touches like columns, cornices, and ornament, seen as antithetical to goals of socialism.

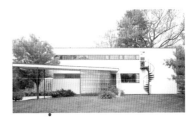

Impression: Depression

During the Great Depression of the 1930s, with 25% of the American population unemployed, Franklin Delano Roosevelt initiates programs to employ the country's artists: painters, photographers, writers, and actors. The Farm Security Administration commissions photographers to show "America to Americans." Those who record reality with compassion, to reveal injustice and advocate reform, practice what's known as social documentary photography. Russell Lee, Eudora Welty, and Walker Evans document problems in order to, as photographer Arthur Rothstein says, "justify New Deal legislation that was designed to alleviate them."

1936 Lange's "Migrant Mother" documents grim era when nation's breadbasket becomes a Dust Bowl and the dispossessed flock to California. Sharp focus view of 32-year-old mother and children in pea-picker tent camp. Hungry and desperate, the family ate frozen vegetables left in the fields and birds trapped by the children. More than showing misery, Lange wants to register "their pride, their strength, their spirit."

1939 "The art of Frida Kahlo," according to Surrealist poet Breton, "is a ribbon around a time bomb." Kahlo's "The Two Friedas" explodes with symbolic meaning. Double portrait presents two sides of her nature, connected heart-to-heart by external

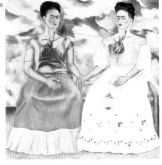

artery. One aspect is in European dress, wearing virginal white, spotted with blood. The other, in folkloric Mexican dress, holds miniature portrait of her husband, painter Diego Rivera, who'd just asked her for divorce. Turbulent sky and dream-like imagery evoke heartbreak, suffering.

Mr. Right

First architect to think outside the box, Frank Lloyd Wright devotes himself to "reaching out and amplifying space, dragging things in from the outside." He invents the open plan, in which unobstructed space flows freely from room to room and the exterior merges with the inside. His early Prairie Houses have long, low roof lines, like flat prairies, with space visually expanded through bands of windows and spreading, cantilevered roofs and balconies. Using poured concrete as a sculptural material, his designs enhance a site's underlying geometry by conforming to the setting, unifying it with the structure. In the Guggenheim Museum's circular ramps, he finally—the year of his death, 1959—achieves a building of continuously unspooling space.

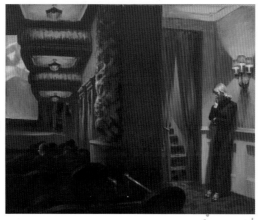

1939 Hopper makes the city his theme, expressing through light the feel of a locale and its inhabitants. In "New York Movie," solitary usher is high-lighted, immobile, isolated from spectators who sit in the gloom. In Hopper's hands, light models forms, estab-lishes mood of loneli-ness and silence, and creates drama through light/dark contrasts.

1940

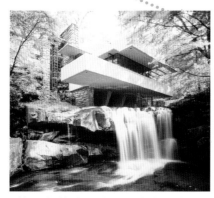

1937–39 Most acclaimed house in U.S. is Wright's Fallingwater, masterpiece of organic architecture that appears to grow from site. House straddles cascade; jutting balconies and stone walls seem extension of rock ledges. Stacked shelves of concrete terraces radiate out from an actual boulder in stream bed, which is embedded in floor in front of hearth. Horizontal sweep balanced by vertical accent of chimney, anchoring house to ledge and echoing direction of falls.

Early 1940s Cornell collects photos, postcards, pieces of clocks, bits of mirrors to construct shadow boxes like the toy stages he played with as a child. French doll in vintage costume in "Untitled (Bébé Marie)" resembles Surrealist assemblage. Twigs and glass front conceal and protect her from viewer, creating sense of mystery, entrapment, and longing. Poet John Ashbery praises enigmatic boxes: "We all live in his enchanted forest."

1940–41 Lawrence creates 60 paintings in "The Migration of the Negro Series," including "They Were Very Poor." Pictures and captions recount African-Americans leaving the south for the industrial north, in search of opportunity. Lawrence employs tempera like poster paints he used as a child in Harlem. Simplified forms and pure, flat colors resemble posters. An admirer of Daumier and Goya, whom he calls "Forceful. Simple. Human," Lawrence focuses on human subject. Bare composition of rectangles implies sparseness of his subjects' meal. Yet they sit erect, with heads bowed, dignified, not abject.

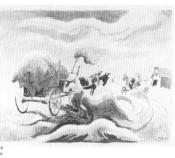

1945 Opposing the avant-garde, Benton idealizes rural life in "The Hayfield." Muscular figures, surging forms, lush colors present ordinary Americans as heroes, landscape as dynamic force. Considers modern art "intellectually diseased," too removed from real life. Speaks of conversion to conservatism: "I wallowed in every cockeyed-ism that came along, and it took me ten years to get all that modernist dirt out of my system."

The American Scene: Cornbelt Art

American Scene painters like Thomas Hart Benton, John Curry, and Grant Wood react against abstract art, choosing to update American myths in a robust, naturalistic style. Popular in the 1920s and '30s, they paint vernacular scenes and murals romanticizing the frontier spirit. Wood, whose "American Gothic"—with a farmer gripping a pitchfork—is the genre's most famous painting, says greatest inspiration comes when he's "milking a cow."

1943 Gorky influences advent of Abstract Expressionism in U.S. He develops composition in preparatory drawings, but final painting evolves through improvisation, becomes field of unloosed energy. Warm, wet-looking colors like red and egg-yolk yellow jump out from background of cool gray in "Waterfall." Images fluidly expressionistic but are abstracted versions of biomorphic forms.

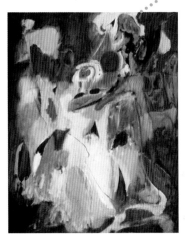

1947 Giacometti's stick-like sculpture, "Man Pointing," seems anonymous and alone, surrounded by a vast void. Emaciated figure suggests mass destruction of war. Sense of solitude implies Existentialist philosophy, in which frail human being solely responsible for finding meaning in life. Rough surface, as if corroded or charred, matches post-World-War-II landscape, scarred and pitted.

1950 Lassaw pioneers improvisational techniques in sculpture "Milky Way." Considers "art as a process that is started by the artist" until the point when "the work of art begins to *work*." Welds thin rods into open, calligraphic structures. Airy mazes refer to cosmic forces.

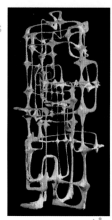

1950–52 Abstract Expressionist art records painter's creative struggle, as in slashing brush-strokes of de Kooning's "Woman, I." Traces of numerous revisions show on canvas, as do violence and velocity with which paint is manipulated. Aggressive attack lends ferocity, destroys static concept of figure in a field. Picture is synthesis of accidental effects and constant reworking. "I paint this way because I can keep putting more and more things in it— drama, anger, pain, love, a horse, my ideas about space."

1950

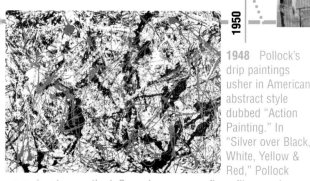

1948 Pollock's drip paintings usher in American abstract style dubbed "Action Painting." In "Silver over Black, White, Yellow & Red," Pollock uses signature method. Spreads canvas on floor, flings and pours paint across surface to exploit gravity, momentum, and chance effects. All-over web of paint fuses matte and glossy, blurred and precise passages, dense and loose areas. "NO CHAOS DAMN IT," Pollock wires response to critic, insisting energetic rhythm of work has coherent structure.

1952–53 Most famous British artist of 20th century, Moore celebrates concept of "truth to material." Intrinsic qualities (texture, grain, etc.) of stone, wood, or metal are integral to work. "King & Queen" is smoothly abstracted version of male and female figures, in which voids and solids are equally important. Space and mass seem to interpenetrate.

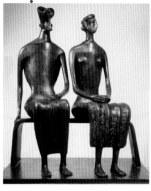

Abstract Expressionism

Artists called Abstract Expressionists include Jackson Pollock, Willem de Kooning, Franz Kline, and Robert Motherwell. Also known as The New York School, the essence of this post-war art movement, as Pollock says, is "energy made visible." Revolting against the dominant realistic trend in American art, they express their emotions through abstract means (color and gesture), with the painting as a record of spontaneous activity. The style emphasizes each artist's idiosyncratic brushwork and the expressive potential of paint and its application for textural effect. For the first time, New York replaces Paris as the center of the avant-garde.

1955 Johns creates skewed replicas of ordinary objects like "Target with 4 Faces." He combines melted wax mixed with pigment (encaustic) over layers of newsprint. Lumpy texture transforms flat target, so image straddles line between the known and the new. Using target as subject, something "the mind already knows," Johns explains, provides "room to work on other levels." He chooses "objects so familiar that the spectator can cease to think about them and concentrate on the poetic qualities of the picture itself." Cut-off, 3-D faces at top add ambiguity and paradox.

Art in the Gap

Robert Rauschenberg drags art back from wallowing in abstraction and purely internal meaning, bringing the outside world in again. "Painting relates to both art and life," he says, adding, "I try to act in the gap between the two." From this point, art makes the transition from gung-ho, painterly abstraction, which takes itself deadly seriously, to a more democratic openness to found materials and pop culture. Rauschenberg incorporates everything into his work, from a stuffed goat encircled by a tire to tin cans, neckties, and lightbulbs.

1953 Bacon transforms Baroque-era portrait into wail of despair in "Study after Velázquez's Portrait of Pope Innocent X." Instead of objective rendering of subject, image becomes vehicle to express artist's private anguish. Disturbing portrayal of pope's silent scream is conveyed through aggressive, smeared brushwork and isolated figure trapped by golden chair, as if in cage. Bacon wishes his paintings "to look as if a human being had passed between them, like a snail, leaving a trail of the human presence and memory trace of past events as the snail leaves its slime."

1955 Rauschenberg's "Bed" originates in poverty—the artist couldn't afford supplies so scavenges debris to use as material, and invents 3-D collage, hybrid of painting and sculpture, which he calls a "combine." Attaches quilt, pillow, sheet to wood support, applies paint to transform homely objects into assemblage. Work shows influence of composer John Cage's stress on role of chance and randomness, idea of integrating art and life. "A picture is more like the real world," Rauschenberg says, "when it's made out of the real world."

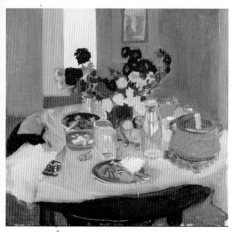

1955 In "Still Life with Casserole," Porter's luminous imagery drawn from daily life straddles line between representation and abstraction. Porter creates intimate domestic scenes and sensual summer landscapes through Abstract Expressionist techniques of vigorous brush strokes and broad paint handling. Re-invents realism at mid-century.

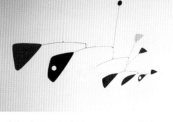

1955 Calder is first to liberate sculpture from stasis. Invents "Mobile" (hanging sheet-metal and wire construction of playful, abstracted shapes activated by breeze) and stabile (large, flat steel shapes on tapering legs). Inspired by idea of setting Mondrian's colors in motion, he uses weights to create movement of floating shapes. "When everything goes right, a mobile is a piece of poetry that dances with the joy of life and surprises."

1959 Attenuated, pole-like "Sleeping Figure, II" by Louise Bourgeois has abstracted limbs, suggesting human being, but upright posture and title invoke paradox. Bronze is 6'3", combines Surrealist ambiguity and Bourgeois' Freudian emphasis on underlying family dysfunction. Alienation and anger are frequent motifs in her autobiographical art. "The gift of an artist," she says, is "access to what makes us tick deep in the unconscious."

1960–61 Rosenquist, originally a commercial sign painter, paints billboard-sized canvases with graphic impact of ads. "President-Elect" reflects discovery that even fragments of images (President Kennedy's face, a slice of cake, a car) are immediately recognizable in gigantic scale. Enlargement expands importance of objects, galvanizes viewer to wrestle with value judgments. Part of the Pop Art movement, Rosequist uses artifacts from mass culture in his art, but says it's not the objects but "the relationship between them [that] may be the subject matter." Painting implies politicians are sold to the public like consumer products.

1960–61 Rothko uses color and light as portal into spiritual realm. He balances two complementary colors of "Untitled" in separate, suspended bands, but they contrast and intensify each other, through their floating proximity. Blurred, ragged edges of rectangles and subtle modulation of matte surface achieve three-dimensional effect. Large scale of glowing canvases intended to envelop viewer in transporting experience.

1962 Tony Smith's irregular shapes are intended to be mysterious "presences" that change as viewer walks around them. Black-painted, steel sculpture "Free Ride" is designed to interact with nature, so "trees or plants, rocks, can combine with the piece in forming space around it." Openness and mutability, depending on viewpoint, are key. Sculptures "may be seen as interruptions in an otherwise unbroken flow of space." Smith evolves sculptures through "spontaneous generation."

Pop Goes the Art

A major movement in the '60s and '70s, Pop art rejects the extreme subjectivity and emotional excess of Abstract Expressionism. Instead of the tortured soul, popular culture—like advertising, movies, and comic strips—inspires work by Warhol, Lichtenstein, and Oldenburg. "The Pop artists did images that anybody walking down Broadway could recognize in a split second." Warhol says, "all the great modern things that the Abstract Expressionists tried so hard not to notice at all." Their technique derives from methods of mass reproduction to eliminate the personal signature of the artist.

Color Field Painting

Barnett Newman, Mark Rothko, and Ad Reinhardt pioneer an abstract style that evokes the sublime. These Color Field painters cover the canvas with flat paint without calling attention to the painter's hand in applying brushstrokes. Their goal is to saturate the viewer's eyesight with a field of color to spur meditation. They avoid the intense physicality of Abstract Expressionism, concentrating on a purely visual experience of color.

1962 Hofmann creates tension between forms and space in "Memoria in Aeternum." Exemplifies "push-and-pull" theory, in which impressions of flatness and depth, stasis and movement, oscillate. Yellow and red rectangles against murky, striated background, seem to zip up and down like an elevator and both recede and advance. Color and shape interact dynamically. "The mystery," of painting, Hofmann says, "is based upon the dualism of the two-dimensional and three-dimensional."

1962 Warhol selects low-brow, commercial products like "Campbell's Soup Cans" as subject of Pop art. Consumer culture is both source of art and object of implicit criticism. Warhol manufactures repeated, serial images (an ironic reversal of the concept of original works of fine art), often left to assistants to execute, negating individuality of subject and artist himself.

Conceptual Art

Sol LeWitt provides the rationale for this movement of the 1960s and '70s: "The idea itself, even if not made visual, is as much a work of art as any finished product." Besides LeWitt, Conceptual artists include Baldessari, De Maria, and Kosuth. Reacting against the increasingly commercial concerns of the art world, these artists seek to "de-materialize" the art object, making art a document of an artist's thinking, instead of a crafted product to be displayed and sold. The burden of interpretation shifts to the audience. In Baldessari's text- and media-based Post-Modern art, the goal is to knock art off its pedestal and create a dialogue with the viewer.

1963 A serious joker, Lichtenstein adopts comic-book imagery and parodies mechanical technique in "Whaam!" Imagery is two-dimensional, but complex subject of war contradicts surface juvenility. Clichéd, melodramatic dialogue appears ridiculous in large-scale format. Enlarged Benday dots used for commercial reproduction become visual shtick, undermining pomposity of high art. Depersonalized technique clashes with emotional content, rendering hyped-up "message" trite and synthetic.

1964 A former riveter at an auto plant, David Smith puts welding skills to use in "Cubi XIX," a polished, stainless-steel sculpture. Burnished surface, meant to be seen outdoors, changes color depending on light and sky. Cantilevered beams and cubes seem in unstable tension, contradicting their mass. Dynamic compositions, though abstract, refer to human figure.

1965 Chamberlain's "Untitled," composed of glossy, steel automobile parts, fuses exuberant force of Abstract Expressionism and Pop art's use of consumer products. Using his trademark car parts, he extends collage process into three dimensions, composing sculpture spontaneously, aided by acetylene torch, compactor, baler, and band saw. "The idea," Chamberlain says, "is to use the materials that are here now."

1965–67 Motherwell explains: "Abstract art is stripped bare of other things in order to intensify it, its rhythms, spatial intervals, and color structure." Although nonrepresentational, he insists abstract art contains content, as in "Elegy to the Spanish Republic" expressing despair over Spanish Civil War. Subject is both lament and metaphor for continuum between life and death. Ovoid shapes border vertical rectangles in varying rhythm, as if biomorphic forms crashing into wall. Black absorbs light, while ocher representing earth and green, symbol of grass, show interrelation of death and life.

1971 Kelly gives physical form to perceptions of nature: a shadow or detail of a building or landscape. He distills and translates these visual perceptions into pure form and color. "Blue Yellow Red III" relates to an earlier three-panel painting, "Train Landscape" of 1952, which shows fields from his travels in France in greens and yellow. His signature flat imagery and abstracted motifs are presented here in three primary colors.

1970

1969 Serra explores physical properties—malleability and heaviness—of lead in "Shovel Plate Prop." One sheet of lead is rolled to form "handle" or prop, which holds rectangular sheet of "shovel" upright through balance of weight and thrust. Two elements support each other, without welding, in gravity-defying equilibrium. Threat of collapse creates tension, which Serra relates to instability during Vietnam War: "the weight of repression, the weight of constriction, the weight of government, . . . the weight of destruction."

1970 Hesse's "Untitled (Study for 7 Poles)" illustrates Post-Minimalist stress on materials, labor, and tactile, visceral qualities of sculpture. Hesse arranges painted plaster rods in armature, connected by wires wrapped with copper, gauze, and string. She juxtaposes off-kilter geometric structure with dangling lines to bury the Minimalist grid under layers of chaotic conglomeration. Gravity and entropy affect the work, replacing the clarity and austerity of Minimalism. Before dying at age 34, Hesse returns handmade craft to sculpture.

Hard vs. Soft Edge

Flat, anonymous surfaces treated as a single unit, with no distinction between foreground and background, are known as Hard Edge Paintings. Ellsworth Kelly, Frank Stella, and Kenneth Noland create geometric works with a machine-made look, precise and anonymous. The stark lines of these works contrast to the blurred edges of stain paintings by Helen Frankenthaler and Morris Louis, whose liquid swaths of color create an enveloping environment.

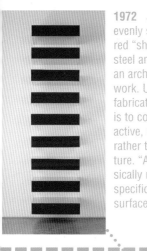

1972 Judd arranges 9 evenly spaced, rectangular, red "shelves" of stainless steel and Plexiglas in "Stack," an archetypal Minimalist work. Units are identical, fabricated by machine. Goal is to confront viewer with an active, rhythmic "presence" rather than a passive sculpture. "Actual space is intrinsically more powerful and specific than paint on a flat surface."

1974 Master of collage Bearden mixes vividly colored paper and magazine cutouts in "Empress of the Blues," tribute to singer Bessie Smith. Bearden, who heard Smith perform during his youth in the Harlem Renaissance days, takes jazz and blues as both his inspiration and subject. Staccato snippets and offbeat rhythms of composition approximate musical innovations of jazz. Adapting jazz aesthetic to art, Bearden compares blank space to intervals of silence between notes. He repeats colors and motifs, like recurring chords, to unify patchwork of fragments.

1972 German artist Beuys is shamanistic teacher, influencing generations of Post-Modern artists. Calls himself a "transmitter" trying to communicate what art's about. "The function of all art," according to Beuys, is to "question the basic premises of the prevailing culture." Focusing on even exchange between artist and audience, he stages performance art—sits with his head smeared with honey, covered with gold leaf, orating to a dead hare. "We Can't Do It without the Rose" invites viewer's interpretation. Beuys strives to connect art with life, to make it instrument of healing, social transformation, environmental responsibility.

1974 Frankenthaler creates "Spring Bank" through her trademark soak-stain technique. After watching Jackson Pollock at work, she invents method in 1952 of thinning paint with turpentine, then pouring diluted color on unprimed canvas so it penetrates fabric. She manipulates flow of paint by brushing, blotting, and rubbing until spontaneously generated imagery merges with matrix of canvas. Large-scale images have atmospheric, lyrical quality; figure and background fused.

1974 During Minimalist phase, painter Stella attempts to rid art of personal, emotional, or anecdotal references. "A painting is a flat surface with paint on it—nothing more" and "What you see is what you see" are signature statements. Regular lines reflect format of canvas in "Single Concentric Squares (violet to red violet half-step)." His later shaped canvases emphasize existence of artwork as tangible object rather than illusionistic portrayal of something else.

Minimalism

Reacting against Pop art's appropriation of messy reality and Abstract Expressionism's cult of personality, stressing the imprint of an artist's hand, Minimalism evolves in the early 1960s. Sculptors like Judd, André, Flavin, Morris, and LeWitt pare their works to geometric abstraction, constructed with engineering precision from industrial materials. The first international art movement pioneered exclusively by American-born artists, Minimalism expresses the ideal of producing new forms rather than recycled images from the past. A sleek, machined look characterizes the sculptures, often consisting of prefabricated units in a series.

1976 Christo and Jeanne-Claude erect "Running Fence"—18-foot-high billows of white nylon run for 24.5 miles in a continuous ribbon over the hills north of San Francisco. The environmental art project is visible from public roads for two weeks before being dismantled. Jeanne-Claude: "We want to create works of art of joy and beauty." Christo: "Our work is a scream of freedom."

1979 Finster, most well-known folk artist in America, combines text and visual forms in "sacred art" illustrating Biblical passages to instruct the soul. "The Model of Super Power Plant" is made of discarded television parts and adorned with religious imagery. Finster calls himself a "man of visions," uses art to preach evangelical message.

1977 Piano & Rogers design seminal work of High-Tech architecture, the Pompidou Center, turning ducts and pipes into decorative, color-coded façade. Service components like escalators, pipes, corridors, and framework are placed outside glass walls to maximize interior space. High-Tech architects like Piano & Rogers practice expressive use of industrial materials and latest technology, boldly exhibiting structural underpinnings.

1982 Nelson scavenges bits of wood from streets, puts them in boxes, paints boxes and objects black. Within each box, she constructs compositions, then stacks the compartments to form a walled environment. In "Reflections of a Waterfall I," single color unifies diverse components.

1982 Originating as a graffiti artist in the late 1970s, Basquiat produces canvases of emotional depth and implicit social criticism before dying of drug overdose at age 27. "All Colored Cast," painted in self-consciously "primitive" style, uses text and disparate imagery to explore identity issues and fear of mortality. The son of Haitian-American father and Puerto Rican mother, Basquiat identifies with historic black figures like Toussaint L'Ouverture, liberator of Haiti.

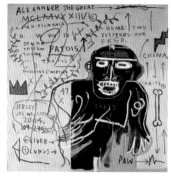

1982 Sherman produces "dramatized self-portraits, as in "Untitled." Her film-still series implies a narrative, but each pose presents her as a different character in trite, B-movie roles that often feature a female-in-jeopardy or woman-as-sex-object theme. She effaces her own identify with elaborate disguises and contrived settings, suggesting that Hollywood commodifies and stereotypes women.

Performance Art

A multimedia form of art growing out of the European Fluxus movement and the Happenings of the late 1950s and '60s, Performance Art involves activities presented before a live audience. Vito Acconci, Laurie Anderson, Chris Burden, Gilbert and George, and Marina Abramovic stage performances involving physical trials, dance, music, verbal presentations, theater, and video. The goal is direct communication with viewers. Abramovic lies down in the center of a fire, passes out from lack of oxygen, and is rescued by onlookers. The message: however committed an artist is, the viewer must participate with equal fervor.

1983 Post-Minimalist artist Nauman's "Human/Need/Desire" transforms words into images, dazzles viewer with neon light in parody of Minimalist art. Use of neon tubes associated with advertising to express human aspirations like hope, dream, and desire (a typically elevated subject of art) underscores irony, contradiction. His work, in general, is rooted in physical experience of the body.

1984 German painter Kiefer explores suppressed memories and taboo symbols that evoke national trauma of Nazi past. Heroically scaled, charred landscape seems ravaged, like metaphor for guilt of Holocaust. Kiefer covers full-sized photo with thick layers of paint and straw, but dark palette shimmers with glints of light. Title, "Nigredo," suggests hope. Refers to chaotic stage before purification in alchemical process, which transforms dross to gold.

Photo-based Art

In the 1960s and '70s, artists use the camera to create a dialogue between art and popular culture. Some, like Baldessari and Acconci, explore the camera's ability to infuse a banal subject with significance, while Warhol questions the artist's role as a creator by taking pictures in coin-operated photo booths. Artists challenge the idea of a photograph as objective documentation, instead using it as an instrument of invention. These artists manipulate, fictionalize, and change the meaning of photos through their intervention, a process facilitated by digital photography. Carrie Mae Weems challenges racial and sexual stereotypes, while Struth, Gursky, and Jeff Wall's lush, large-scale color photos frame thought-provoking glimpses of the world. In the 1990s, photography becomes the medium of choice for photographers who make art and artists who make photographs.

1985 Kruger's "We will no longer be seen and not heard" exemplifies photo- and text-based works that both criticize and exploit mass media's power to communicate. By juxtaposing found images and provocative text, she challenges viewer's expectations and questions cultural stereotypes. Her works attack prevailing power structure, in which art and media are directed to and by males. Here, identity of assertive "we" is ambiguous, although message is spelled out in pictures, sign language, gesture, and words.

1987 Brash, intense etching of "Lord Goodman" by Freud illustrates skill of consummate draftsman. Known for disturbing portraits that revel in every crease and wart of human flesh, Freud treats etching plate like canvas. Builds image of massive physical presence through close observation and meticulous composition. Many lines overlap, intersect, seem to recede and advance, suggesting topography of face.

1992 Viola's "Nantes Triptych" video chronicles the body's path from cradle to grave, flanking images of a figure floating in a void with images of a young woman giving birth on one side and a woman nearing death on the other. Artist slows down the motion so the viewer has time to contemplate and experience the implications of his imagery.

Feminist Art

Since the late 1960s, artists like Judy Chicago, Barbara Kruger, Ana Mendieta, the Guerrilla Girls, Lorna Simpson, Sue Williams, and Faith Ringgold create art that explores the social and historical conditions of women. By reinterpreting history, they discover sexist bias in the patriarchal society and art world. Feminist art addresses the politics of identity: sexuality, social class, racial and cultural back-grounds, but without reducing issues to simplistic propaganda or attacks.

1994 Murray suggests domestic chaos by combining abstracted chair, twisted stairs, chain for glasses, and "Arm-Ear." Border of shaped canvas zigzags, stairs are dysfunctional, and surface bursts upward, barely contained by screw. Murray transforms static objects into dynamic jumble in uneasy tension. Style derives from bright olors of comics and her subjects from areas traditionally associated with women. Her contribution: elastic surfaces of fractured reliefs. More than Pop art, the canvases pop out.

Video Art

Nam June Paik invents video art in 1965, creating installations animated by video monitors, which he called a "TV version of Vivaldi." In video art (video made by visual artists), the medium itself—not the subject or content recorded by the medium— is the message. Artists like Bill Viola, Tony Oursler, Gary Hill, Rebecca Horn, Bruce Nauman, and Matthew Barney use elec-tronic media as an expres-sive artistic tool, extending the methodology of con-temporary art into a kinetic visual realm. In contrast to cinema, video art may be non-narrative, without performers or dialogue. The ease of editing and manipulating digital tapes with computer software catalyzes a burst of artistic experimentation in the '90s.

1993–94 Twombly reinvents traditional subject, "The Four Seasons: Spring." Encrusted layers partially cover prior words, images, and markings with paint so they both emerge and disappear, tweaking viewer's curiosity about what lies beneath the surface. He rubs gobs of yellow and red paint on canvas, scratches with pencil and crayon, and ladles on liquid paint, allowed to run freely. Working in Italy, he investigates relationship between self and classical history, the body and language. The transitory quality of life and human traces is a constant theme, as is idea of metamorphosis.

1997 Known for portraits of monumental heads, Close first produced images of photo-realist accuracy before switching to various painterly techniques. He takes large-scale Polaroid headshots of subject, then breaks components into grid and applies paint in thumbprints or dots of color to build image. Hundreds of pixilated squares of paint coalesce into "Self-Portrait." Due to systematic approach, colorful, patterned canvases have abstract quality when viewed up close. Works range from neutral mug shots to psychologically revealing.

Photo Credits

Cover Image: Paul Cézanne, **"Still Life with Apples and Oranges"**: Erich Lessing/Art Resource, NY.

THE PREHISTORIC ERA THROUGH THE MIDDLE AGES
Venus of Willendorf: Erich Lessing/Art Resource, NY; **Cave Painting, Chinese Horse**: Art Resource, NY; **Rock Painting, Shaman**: Werner Forman/Art Resource, NY; **Cave Painting, Weary Warrior Returns**: Erich Lessing/Art Resource, NY; **Stonehenge**: Pronin, Anatoly/Art Resource, NY; **Step Pyramid of Djoser**: Erich Lessing/Art Resource, NY; **Line Drawing of Step Pyramid**: Illustration by Lucille Betti Nash; **Pyramids of Giza**: Erich Lessing/Art Resource, NY; **Prince Rahotep and Wife Nofret**: Scala/Art Resource, NY; **Line Drawing of Ziggurat of Ur**: Illustration by Lucille Betti Nash; **Pendant of Eagle with Lion's Head**: Erich Lessing/Art Resource, NY; **Bronze Bust of Sargon I of Nineveh**: Scala/Art Resource, NY; **Babylonian Seal with Ziggurat and Priest**: Erich Lessing/Art Resource, NY; **Alignments of *Menhirs*, Carnac**: SEF/Art Resource, NY; **Cave Painting, Mystical Serpent**: SEF/Art Resource, NY; **Terra-Cotta**

Jar, Jericho: Erich Lessing/Art Resource, NY; **Sphinx of Queen Hatshepsut**: Art Resource, NY; **Queen's Chamber from the Palace of Minos, Knossos, Crete**: Vanni/Art Resource, NY; **Egyptian Wall Painting, Gathering Grapes**: Werner Forman/Art Resource, NY; **"Toreador" Fresco from Knossos**: Scala/Art Resource, NY; **Tutankhamen's Gold Face Mask**: Erich Lessing/Art Resource, NY; **Bust of Nefertiti**: Vanni/Art Resource, NY; **Four Stone Colossi of Ramses II**: Bridgeman-Giraudon/Art Resource, NY; **Line Drawing of Egyptian Column Styles**: Illustration by Lucille Betti Nash; **Line Drawing of Sargon II's Citadel**: Illustration by Lucille Betti Nash; **Lion's Gate Arch, Mycenae**: Erich Lessing/Art Resource, NY; **Dying Lion Bas-Relief, Nineveh**: HIP/Art Resource, NY; **Ishtar Gate, Babylon**: Erich Lessing/Art Resource, NY; **Greek Black-Figured Winecup of Dionysus**: Erich Lessing/Art Resource, NY; **Greek Marble Statue, *Kore*, Acropolis**: Nimatallah/Art Resource, NY; **Jade Dragon Pendant**: Réunion des Musées Nationaux/Art Resources, NY; **Red-Figured Vase, Apollo and Artemis**: Bridgeman-Giraudon/Art Resource, NY; **Line Drawings of the Acropolis, the Parthenon**: Illustrations by Lucille Betti Nash; **Ionic Erechtheum Caryatid Porch**: Vanni/Art Resource, NY; **Line Drawing of the Temple of Apollo**: Illustration by

Lucille Betti Nash; **Epirus Amphitheater**: Vanni/Art Resource, NY; **Etruscan Bronze Statue**: Scala/Art Resource, NY; **Chinese Lacquered Box**: HIP/Art Resource, NY; **Hopewell Carving, Bird Claw**: Werner Forman/Art Resource, NY; **Nike of Samothrace**: Erich Lessing/Art Resource, NY; **Pergamon Altar**: Vanni/Art Resource, NY; **Mosaic of Battle of Issus, Pompeii**: Erich Lessing/Art Resource, NY; **Line Drawing of Greek Orders**: Illustration © Ken Scaglia; **Villa of the Mysteries Fresco, Pompeii**: Scala/Art Resource, NY; **Line Drawing of Arch v. Vault**: Illustration by Lucille Betti Nash; **Colosseum, Rome**: SEF/Art Resource, NY; **Roman Aqueduct, Segovia, Spain**: Bridgeman-Giraudon/Art Resource, NY; **Line Drawing of Basilica Ulpia, Trajan's Forum**: Illustration by Lucille Betti Nash; **Pantheon, Interior**: Scala/Art Resource, NY; **Chinese Bronze Flying Horse**: Erich Lessing/Art Resource, NY; **Hadrian's Villa, The Canopus**: Scala/Art Resource, NY; **Arch of Constantine**: Scala/Art Resource, NY; **Line Drawing of Pantheon**: Illustration by Lucille Betti Nash; **Old Basilica of St. Peter**: Alinari/Art Resource, NY; **Hagia Sophia, Interior**: Erich Lessing/Art Resource, NY; **Line Drawing of Hagia Sophia**: Illustration by Lucille Betti Nash; **Mosaic of Empress Theodora**: Cameraphoto Arte, Venice/Art Resource, NY;

Horyu-Ji Temple: Werner Forman/Art Resource, NY; **Ise Shinto Shrine**: Scala/Art Resource, NY; **Dome of the Rock**: Scala/Art Resource, NY; **Snarling Camel Terra Cotta**: Werner Forman/Art Resource, NY; **Courtyard of Great Mosque, Damascus**: Bridgeman-Giraudon/Art Resource, NY; **Mosque at Córdova, Spain**: Art Resource, NY; **Palatine Chapel, Interior**: Vanni/Art Resource, NY **Palatine Chapel, Interior**: Vanni/Art Resource, NY; **Book of Kells, Illuminated Manuscript**: Art Resource, NY; **Great Mosque of Samarra**: SEF/Art Resource, NY; **Gu Hongzhong, "The Night Revels of Han Xizai"**: Werner Forman/Art Resource, NY; **Kukulcan Pyramid, Chichen Itza**: Erich Lessing/Art Resource, NY; **Ceramic Teabowl of Song Dynasty**: Réunion des Musées Nationaux/Art Resources, NY; **"Early Spring," Chinese Hanging Scroll**: Lee & Lee Communications/Art Resource, NY; **Nave of Saint Sernin**: Scala/Art Resource, NY; **Line Drawing of Saint Sernin**: Illustration by Lucille Betti Nash; **Statue of St. Peter at Moissac Cloister**: Scala/Art Resource, NY; **Angkor Wat**: Vanni/Art Resource, NY; **Anasazi Cliff Dwellings**: Werner Forman/Art Resource, NY; **Chartres Cathedral Saints**: Foto Marburg/Art Resource, NY; **Fortified Village of Carcasonne**: Vanni/Art Resource, NY; **Line Drawing of Amiens Cathedral**:

Illustration by Lucille Betti Nash; **Great Mosque**: Werner Forman/Art Resource, NY; **Stained Glass at Sainte-Chapelle**: Erich Lessing/Art Resource, NY; **Notre Dame Cathedral**: Erich Lessing/Art Resource, NY; **Great Amida Buddha**: Werner Forman/Art Resource, NY; **Line Drawing of Notre Dame**: Illustration by Lucille Betti Nash; **Terra-Cotta Figure from Djenné**: Werner Forman/Art Resource, NY; **Giotto di Bondonne, "The Lamentation of Christ"**: Scala/Art Resource, NY; **Line Drawing of Tenochtitlan**: Illustration by Lucille Betti Nash; **Byzantine Icon of Madonna and Child**: Erich Lessing/Art Resource, NY; **Alhambra's Court of the Lions**: Scala/Art Resource, NY; **Forbidden City, Beijing**: Erich Lessing/Art Resource, NY.

RENAISSANCE TO NEOCLASSIC ART

Filippo Brunelleschi, San Lorenzo, Interior, Central Nave; Scala/Art Resource, NY; **Limbourg Brothers, "Les Très Riches Heures du Duc de Berry"**: Réunion des Musées Nationaux/Art Resources, NY; **Filippo Brunelleschi, Duomo of Florence Cathedral**: Scala/Art Resource, NY; **Masaccio, "The Tribute Money"**: Scala/Art Resource, NY; **Donatello, "The Prophet"**: Scala/Art Resource, NY; **Jan van Eyck, "Arnofini Wedding"**: Erich Lessing/Art Resource, NY; **Fra Angelico, "Annunciation"**: Scala/Art Resource, NY; **Line Drawing of Brunelleschi, Santo Spirito**: Illustration by Lucille Betti Nash; **Leon Battista Alberti, Santa Maria Novella, Florence**: Erich Lessing/Art Resource, NY; **Machu Picchu**: Nick Saunders/Barbara Heller Photo Library, London/Art Resource, NY; **Soami's Garden at the Temple of the Silver Pavilion**: Werner Forman/Art Resource, NY; **Unicorn Tapestry**: Réunion des Musées Nationaux/Art Resource, NY; **Sandro Botticelli, "The Birth of Venus"**: Erich Lessing/Art Resource, NY; **Giovanni Bellini, Barbarigo Altarpiece**: Scala/Art Resource, NY; **Hopi Kachina Doll**: Scala/Art Resource, NY; **Michelangelo Buonarroti, "Pietà"**: Alinari/Art Resource, NY; **Andrea Mantegna, "The Dead Christ"**: Erich Lessing/Art Resource, NY; **Donato Bramante, Tempietto**: Vanni/Art Resource, NY; **Leonardo da Vinci, "Mona Lisa"**: Réunion des Musées Nationaux/Art Resource, NY; **Hieronymus Bosch, "Garden of Earthly Delights"**: Erich Lessing/Art Resource, NY; **Raphael (Raffaello Sanzio), "Madonna of the Finch"**: Alinari/Art Resource, NY; **Giorgione, "The Tempest"**: Cameraphoto Arte, Venice/Art Resource, NY; **Michelangelo Buonarroti, "The Creation of Adam," Sistine Chapel Ceiling**: Erich Lessing/Art Resource, NY; **Correggio, "Mystic Marriage of St. Catherine"**: Erich Lessing/Art Resource, NY; **Humble Administrator's Garden in Suzhou, China**: Werner Forman/Art Resource, NY; **Titian, "Amor Sacro e Amor Profano"**: Alinari/Art Resource, NY; **Matthias Grünewald, "Resurrection"**: Erich Lessing/Art Resource, NY; **Jacopo Pontormo, "Descent from the Cross"**: Erich Lessing/Art Resource, NY; **Albrecht Dürer, "The Open Book"**: Erich Lessing/Art Resource, NY; **Parmigianino, "Madonna with the Long Neck"**: Scala/Art Resource, NY; **Michelangelo Buonarroti, Design for Piazza del Campidoglio**: Erich Lessing/Art Resource, NY; **Agnolo Bronzino, "Portrait of Cosimo I de Medici as Orpheus"**: Philadelphia Museum of Art/Art Resource, NY; **Benvenuto Cellini, Salt Cellar**: Erich Lessing/Art Resource, NY; **Hans Holbein the Younger, "Henry VIII"**: Scala/Art Resource, NY; **Cathedral of St. Basil**: Victor Minca/Art Resource, NY; **Paolo Veronese, "Wedding at Cana"**: Réunion des Musées Nationaux/Art Resource, NY; **Pieter Brueghel the Elder, "Return of the Hunters"**: Erich Lessing/Art Resource, NY; **Andrea Palladio, Villa Rotonda**: Vanni/Art Resource, NY; **Line Drawing of Villa Rotonda**: Illustration by Lucille Betti Nash; **Giambologna, "Rape of the Sabine Women"**: Archive Timothy McCarthy/Art Resource, NY; **Jacopo Robusti Tintoretto, "The Last Supper"**: Cameraphoto Arte, Venice/Art Resource, NY; **El Greco, "Resurrection of Christ"**: Scala/Art Resource, NY; **Michelangelo Merisi da Caravaggio, "Conversion of St. Paul"**: Scala/Art Resource, NY; **Mosaic Tile in Mihrab, Isfahan**: SEF/Art Resource, NY; **Blue Mosque**: Bridgeman-Giraudon/Art Resource, NY; **Peter Paul Rubens, "Descent from the Cross"**: Scala/Art Resource, NY; **Frans Hals, "Banquet of the Officers of the Civic Guard of St. George"**: Erich Lessing/Art Resource, NY; **Artemisia Gentileschi, "Judith Slaying Holofernes"**: Alinari/Art Resource, NY; **Inigo Jones, Banqueting House**: Foto Marburg/Art Resource, NY; **Nicolas Poussin, "Le Grand Bacchanal"**: Erich Lessing/Art Resource, NY; **Taj Mahal**: SEF/Art Resource, NY; **Willem Heda, "Breakfast Table with Blackberry Pie"**: Erich Lessing/Art Resource, NY; **Rembrandt van Rijn, "Anatomy Lesson of Dr. Tulp"**: Erich Lessing/Art Resource, NY; **Francisco Zurbarán, "Still Life"**: Scala/Art Resource, NY; **Anthony van Dyck, Portrait of Charles I Hunting**: Erich Lessing/Art Resource, NY; **Francesco Borromini, Dome of San Carlo alle Quattro Fontane**: Alinari/Art Resource, NY; **Line Drawing of Sant'Ivo alla Sapienza**: Illustration by Lucille Betti Nash; **Maurice-Quentin de La Tour, "The Newborn Child"**: Erich Lessing/Art Resource, NY; **Gian Lorenzo Bernini, "Ecstasy of St. Theresa"**:

Scala/Art Resource, NY; **Claude Lorrain, "The Ford"**: Scala/Art Resource, NY; **Gian Lorenzo Bernini, St. Peter, Piazza**: Scala/Art Resource, NY; **Diego Rodriguez Velázquez, "Las Meninas"**: Erich Lessing/Art Resource, NY; **André Le Nôtre, Garden for Vaux-le-Vicomte**: Erich Lessing/Art Resource, NY; **Jacob van Ruysdael, "Landscape with Shepherds and Peasants"**: Alinari/Art Resource, NY; **Jan Vermeer, "Head of a Girl"**: Scala/Art Resource, NY; **Guarino Guarini, Cupola of Dome at San Lorenzo**: Erich Lessing/Art Resource, NY; **Louis Le Vau and Jules Hardouin-Mansart, Versailles**: Bridgeman-Giraudon/Art Resource, NY; **Sir Christopher Wren, St. Paul, Cathedral**: Scala/Art Resource, NY; **Jules Hardouin-Mansart and Charles Le Brun, Hall of Mirrors, Versailles**: Réunion des Musées Nationaux/Art Resources, NY; **Sir John Vanbrugh, Blenheim Palace**: Foto Marburg/Art Resource, NY; **Jean Antoine Watteau, "Embarkation to Cythera"**: Erich Lessing/Art Resource, NY; **Giovanni Antonio Canaletto, "Grand Canal near the Campo San Vio"**: Scala/Art Resource, NY; **Elizabeth Blackwell, "View of Holkham Hall" (Burlington and Kent, Architects)**: Victoria & Albert Museum, London/Art Resource, NY; **Francois de Cuvillies, Hall of Mirrors**: Erich Lessing/Art Resource, NY; **Giambattista Tiepolo, Fresco in Reception Room of Prince-Bishops' Residence**: Erich Lessing/Art Resource, NY; **Johann Michael Fischer von Erlach, Church of the Holy Trinity**: Erich Lessing/Art Resource, NY; **Thomas Gainsborough, "Conversation in a Park"**: Réunion des Musées Nationaux/Art Resource, NY; **William Hogarth, "Marriage à la Mode"**: HIP/Art Resource, NY; **Zimmermann Brothers, Organ Loft**: Erich Lessing/Art Resource, NY; **Jacques Germain Soufflot, Pantheon**: Erich Lessing/Art Resource, NY; **Francois Boucher, "Three Graces Carrying Amour, God of Love"**: Erich Lessing/Art Resource, NY; **Jean-Baptiste Simeon Chardin, "Basket of Peaches"**: Erich Lessing/Art Resource, NY; **Thomas Jefferson, Monticello**: SEF/Art Resource, NY; **Robert Adam, Painted Chimney Board**: Victoria & Albert Museum, London/Art Resource, NY; **Line Drawing of Boullée, Monument to Newton**: Illustration by Lucille Betti Nash; **Sir Joshua Reynolds, "Three Ladies Adorning a Term of Hymen"**: Tate Gallery, London/Art Resource, NY; **Charles Willson Peale, "George Washington after the Battle of Princeton"**: Réunion des Musées Nationaux/Art Resource, NY; **Claude Nicolas Ledoux, "Director's House"**: Vanni/Art Resource, NY; **John Singleton Copley, "Self-Portrait"**: National Portrait Gallery, Smithsonian Institution/Art Resource, NY; **Jacques Louis David, "Oath of the Horatii"**: Réunion des Musées Nationaux/Art Resource, NY; **Louise Elizabeth Vigee-LeBrun, "Self-Portrait"**: Scala/Art Resource, NY; **Line Drawing of James Wyatt, Fonthill Abbey**: Illustration by Lucille Betti Nash; **William Blake, "Glad Day, or Dance of Albion"**: Art Resource, NY; **Kitagawa Utamaro, "Painting the Lips"**: The New York Public Library/Art Resource, NY; **Francisco de Goya y Lucientes, "Los Caprichos: The Sleep of Reason Produces Monsters"**: Victoria & Albert Museum, London/Art Resource, NY.

THE NINETEENTH CENTURY

Gilbert Stuart, "Thomas Jefferson": National Portrait Gallery, Smithsonian Institution/Art Resource, NY; **Jean Auguste Dominique Ingres, "Napoleon"**: Erich Lessing/Art Resource, NY; **Antonio Canova, "Paolina Bonaparte Borghese as Venus"**: Scala/Art Resource, NY; **Caspar David Friedrich, "Abbey in Oak Forest"**: Bildarchiv Preussischer Kulturbesitz/Art Resource, NY; **Benjamin West, "Benjamin Franklin Drawing Electricity from the Sky"**: The Philadelphia Museum of Art/Art Resource, NY; **Theodore Géricault, "Raft of the Medusa"**: Erich Lessing/Art Resource, NY; **Sir John Soane, Pell Wall House**: Victoria & Albert Museum, London/Art Resource, NY; **John Constable, "Salisbury Cathedral"**: Victoria & Albert Museum, London/Art Resource, NY; **Thomas Cole, "Scene from the Last of the Mohicans"**: Terra Foundation for American Art, Chicago/Art Resource, NY; **Joseph-Nicephore Niépce, Early Camera**: Bridgeman-Giraudon/Art Resource, NY; **Karl Friedrich Schinkel, Altes Museum**: Bildarchiv Preussischer Kulturbesitz/Art Resource, NY; **Eugene Delacroix, "The Death of Sardanapalus"**: Erich Lessing/Art Resource, NY; **Edward Hicks, "A Peaceable Kingdom with Quakers Bearing Banners"**: Terra Foundation for American Art, Chicago/Art Resource, NY; **Katsusika Hokusai, "The Great Wave"**: Erich Lessing/Art Resource, NY; **Honoré Daumier, "Rue Transnonain"**: Erich Lessing/Art Resource, NY; **Ammi Phillips, "Girl in a Red Dress"**: Terra Foundation for American Art, Chicago/Art Resource, NY; **William Fox-Talbot, "Trafalgar Square"**: Digital Image © The Museum of Modern Art/Licensed by SCALA/Art Resource, NY; **Louis Daguerre, "Madame Louise Georgina Daguerre"**: HIP/Art Resource, NY; **Charles Barry and Augustus Pugin, Houses of Parliament**: SEF/Art Resource, NY; **Joseph Turner, "Rain, Steam, and Speed"**: Erich Lessing/Art

Resource, NY; **Sydney Smirke, British Museum**: HIP/Art Resource, NY; **Robert Mills, Washington Monument**: Archive Timothy McCarthy/Art Resource, NY; **Rosa Bonheur, "Plowing in the Nivernais"**: Erich Lessing/Art Resource, NY; **Frederic Church, "Twilight"**: The Newark Museum/Art Resource, NY; **Gustave Courbet, "Burial at Ornans"**: Scala/Art Resource, NY; **Joseph Paxton, Crystal Palace**: Victoria & Albert Museum, London/Art Resource, NY; **Jean-Baptiste Camille Corot, "Diana Bathing"**: Erich Lessing/Art Resource, NY; **Jean Francois Millet, "The Angelus"**: Erich Lessing/Art Resource, NY; **Charles Garnier, Paris Opera**: Bridgeman-Giraudon/Art Resource, NY; **Line Drawing of Palais Garnier**: Illustration by Lucille Betti Nash; **Félix Nadar, Photo of Sarah Bernhardt**: Réunion des Musées Nationaux/Art Resource, NY; **Ando Hiroshige, "Squall at the Large Bridge Ohashi"**: Bridgeman-Giraudon/Art Resource, NY; **Edward Burne-Jones, "Fair Rosamunde and Queen Eleanor"**: Tate Gallery, London/Art Resource, NY; **William Morris, Cherries Room Panel**: Victoria & Albert Museum, London/Art Resource, NY; **Edouard Manet, "Déjeuner sur l'Herbe"**: Erich Lessing/Art Resource, NY; **Fitz Hugh Lane, "Brace's Rock, Brace's Cove"**: Terra Foundation for American Art, Chicago/Art

Resource, NY; **Sanford Robinson Gifford, "Morning in the Hudson, Haverstraw Bay"**: Terra Foundation for American Art, Chicago/Art Resource, NY; **Julia Margaret Cameron, "Beatrice"**: Victoria & Albert Museum, London/Art Resource, NY; **Matthew Brady, "Walt Whitman"**: National Portrait Gallery, Smithsonian Institution/Art Resource, NY; **Henri Labrouste, Reading Hall of French National Library**: Bridgeman-Giraudon/Art Resource, NY; **Albert Bierstadt, "Among the Sierra Nevada Mountains, California,"**: Smithsonian American Art Museum, Washington, DC/Art Resource, NY; **Martin Johnson Heade, "Newburyport Marshes: Approaching Storm"**: Terra Foundation for American Art, Chicago/Art Resource, NY; **Berthe Morisot, "The Cradle"**: Erich Lessing/Art Resource, NY; **Gustave Moreau, "The Apparition"**: Réunion des Musées Nationaux/Art Resource, NY; **Thomas Eakins, "Sailing"**: The Philadelphia Museum of Art/Art Resource, NY; **James Abbott McNeill Whistler, "Nocturne in Black and Gold: the Fire Wheel"**: Tate Gallery, London/Art Resource, NY; **Auguste Renoir, "Ball at the Moulin de la Galette"**: Réunion des Musées Nationaux/Art Resource, NY; **George Inness, "Summer, Montclair"**: Terra Foundation for American Art, Chicago/Art Resource, NY; **George Caleb Bingham, "The Jolly

Flatboatmen"**: Terra Foundation for American Art, Chicago/Art Resource, NY; **Camille Pissarro, "Trees and Flowers: Spring at Pontoise"**: Erich Lessing/Art Resource, NY; **Gustave Caillebotte, "A Paris Street, Rainy Weather"**: Erich Lessing/Art Resource, NY; **Eadweard Muybridge, "Transverse Gallop"**: Image Select/Art Resource, NY; **Alfred Sisley, "The Snow at Louveciennes"**: Scala/Art Resource, NY; **Henri Fantin-Latour, "Nasturtiums"**: Victoria & Albert Museum, London/Art Resource, NY; **Albert Pinkham Ryder, "Moonlight"**: Smithsonian American Art Museum, Washington, DC/Art Resource, NY; **Antoni Gaudí, Church of La Sagrada Familia**: Vanni/Art Resource, NY; **John Frederick Peto, Still Life**: Smithsonian American Art Museum, Washington, DC/Art Resource, NY; **Georges Seurat, "Bathers at Asnières"**: Erich Lessing/Art Resource, NY; **John Roebling, Brooklyn Bridge**: The New York Public Library/Art Resource, NY; **Frédéric Auguste Bartholdi, Statue of Liberty**: Archive Timothy McCarthy/Art Resource, NY; **Augustus Saint-Gaudens, "Adams Memorial"**: Smithsonian American Art Museum, Washington, DC/Art Resource, NY; **William Merritt Chase, "Spring Flowers (Peonies)"**: Terra Foundation for American Art, Chicago/Art Resource, NY; **Eiffel Tower**: SEF/Art Resource, NY; **Jacob August Riis,

"Slum in New York City"**: Snark/Art Resource, NY; **Vincent Van Gogh, "The Starry Night"**: Digital Image © The Museum of Modern Art/Licensed by SCALA/Art Resource, NY; **Richard Morris Hunt, Belcourt Castle**: Scala/Art Resource, NY; **Paul Gauguin, "Arearea, or Joyousness"**: Erich Lessing/Art Resource, NY; **Cecelia Beaux, "Young Woman with a Cat"**: Erich Lessing/Art Resource, NY; **Henri de Toulouse-Lautrec, "Aristide Bruant"**: Scala/Art Resource, NY; **Maurice Denis, "The Green Trees or Beech Trees"**: © ARS, NY/ADAGP, Paris: Réunion des Musées Nationaux/Art Resource, NY; **Childe Hassam, "Horticulture Building, World, Columbian Exposition, Chicago"**: Terra Foundation for American Art, Chicago/Art Resource, NY; **Edvard Munch, "The Scream"**: © The Munch Museum/The Munch-Ellingsen Group/ARS, NY: Erich Lessing/Art Resource, NY; **Winslow Homer, "High Cliff, Coast of Maine"**: Smithsonian American Art Museum, Washington, DC/ Art Resource, NY; **Henry Ossawa Tanner, "The Thankful Poor"**: Art Resource, NY; **Aubrey Beardsley, "The Dancer, Reward"**: Victoria & Albert Museum, London/Art Resource, NY; **Paul Signac, "St. Tropez, Thunderstorm"**: © ARS, NY/ADAGP, Paris : Réunion des Musées Nationaux/Art Resource, NY; **Felix Vallotton, "The Passersby, Street Scene"**:

Erich Lessing/Art Resource, NY; **James Ensor, "Masks and Death"**: © ARS, NY/SABAM, Brussels : Erich Lessing/Art Resource, NY; **Maurice Prendergast, "Franklin Park, Boston"**: Terra Foundation for American Art, Chicago/Art Resource, NY; **Henri Rousseau, "The Sleeping Gypsy"**: Digital Image © The Museum of Modern Art/Licensed by SCALA/Art Resource, NY; **Auguste Rodin, "Balzac"**: Archive Timothy McCarthy/Art Resource, NY; **Joseph Maria Olbrich, Secession House**: Erich Lessing/Art Resource, NY; **Otto Wagner, The Majolika House**: Erich Lessing/Art Resource, NY; **Victor Horta, Living Room**: Erich Lessing/Art Resource, NY; **Edgar Degas, "Dancers"**: Erich Lessing/Art Resource, NY; **Gertrude Käsebier, "The Manger"**: Smithsonian American Art Museum, Washington, D.C./Art Resource, NY; **Robert Henri, "Snow"**: Réunion des Musées Nationaux/Art Resource, NY; **Louis Henri Sullivan, Bayard Building**: Vanni/Art Resource, NY; **Yoruba Figurative Carving**: Werner Forman/Art Resource, NY; **Senufo Hornbill or *Calao* Bird**: Bildarchiv Preussischer Kulturbesitz/Art Resource, NY.

THE TWENTIETH CENTURY
Paul Cézanne, "Still Life with Apples and Oranges": Erich Lessing/Art Resource, NY; **Hector Guimard, Paris Métro Entrance**: Erich Lessing/Art Resource, NY; **Gustav Klimt, "Judith with Head of Holofernes"**: Erich Lessing/Art Resource, NY; **Charles Rennie Mackintosh, House Design**: Victoria & Albert Museum, London/Art Resource, NY; **John Singer Sargent, "Ena and Betty, Daughters of Asher and Mrs. Wertheimer"**: Tate Gallery, London/Art Resource, NY; **Mary Cassatt, "Mother and Child"**: Bridgeman-Giraudon/Art Resource, NY; **Paul Cézanne, "Mont Sainte-Victoire"**: The Philadelphia Museum of Art/Art Resource, NY; **Aristide Maillol, "The Mediterranean"**: © Artists Rights Society (ARS), NY/ADAGP, Paris: Digital Image © The Museum of Modern Art/Licensed by SCALA/Art Resource, NY; **Odilon Redon, "Dream"**: Erich Lessing/Art Resource, NY; **Josef Hoffmann, Palais Stoclet**: Foto Marburg/Art Resource, NY; **Maurice de Vlaminck, "Restaurant de la Machine at Bougival"**: © Artists Rights Society (ARS), NY/ADAGP, Paris: Erich Lessing/Art Resource, NY; **Andre Derain, "Big Ben"**: © Artists Rights Society (ARS), NY/ADAGP, Paris: Bridgeman-Giraudon/Art Resource, NY; **Paula Modersohn-Becker, "Mother and Child"**: Erich Lessing/Art Resource, NY; **Adolf Loos, American Bar**: Erich Lessing/Art Resource, NY; **Pablo Picasso, "Les Desmoiselles d'Avignon"**: © Estate of Pablo Picasso/Artists Rights Society (ARS), NY: Digital Image © The Museum of Modern Art/Licensed by SCALA/Art Resource, NY; **John Sloan, "Throbbing Fountain, Madison Square"**: Art Resource, NY; **Henri Matisse, "The Dance"**: © Succession H. Matisse, Paris/Artists Rights Society (ARS), NY: Digital Image © The Museum of Modern Art/Licensed by SCALA/Art Resource, NY; **Marc Chagall, "I and the Village"**: © Artists Rights Society (ARS), NY: Digital Image © The Museum of Modern Art/Licensed by SCALA/Art Resource, NY; **Georges Braque, "Still Life with the word 'VIN'"**: © Artists Rights Society (ARS), NY/ADAGP, Paris: The Philadelphia Museum of Art/Art Resource, NY; **Marcel Duchamp, "Nude Descending a Staircase"**: © Artists Rights Society (ARS), NY/ADAGP, Paris/Succession Marcel Duchamp: The Philadelphia Museum of Art/Art Resource, NY; **Egon Schiele, "Self-Portrait with Bent Head"**: Erich Lessing/Art Resource, NY; **Emil Nolde, "Head of a Woman"**: © Nolde Stiftung Seebüll: Digital Image © The Museum of Modern Art/Licensed by SCALA/Art Resource, NY; **Umberto Boccioni, "Unique Forms of Continuity in Space"**: Digital Image © The Museum of Modern Art/Licensed by SCALA/Art Resource, NY; **Ernst Ludwig Kirchner, "Street, Berlin"**: © by Ingeborg & Dr. Wolfgang Henze-Ketterer, Wichtrach/Bern: Digital Image © The Museum of Modern Art/Licensed by SCALA/Art Resource, NY; **Oskar Kokoschka, "Bride of the Wind"**: © Artists Rights Society (ARS), NY/ProLitteris, Zürich: Erich Lessing/Art Resource, NY; **Giorgio de Chirico, "The Enigma of Departure"**: © Artists Rights Society (ARS), NY/SIAE, Rome: Scala/Art Resource, NY; **Elie Nadelman, "Man in the Open Air"**: Reproduced by Permission of the Elie Nadelman Estate: Digital Image © The Museum of Modern Art/Licensed by SCALA/Art Resource, NY; **Kazimir Malevich, "8 Red Rectangles"**: Art Resource, NY; **Wassily Kandinsky, "Composition"**: © Artists Rights Society (ARS), NY/ADAGP, Paris: Erich Lessing/Art Resource, NY; **Eugène Atget, "St. Cloud"**: Digital Image © The Museum of Modern Art/Licensed by SCALA/Art Resource, NY; **Liubov Popova, "Composition"**: Erich Lessing/Art Resource, NY; **George Bellows, "A Stag at Sharkey's"**: Art Resource, NY; **Amedeo Modigliani, "Reclining Nude"**: Scala/Art Resource, NY; **Georgia O'Keeffe, "Evening Star III"**: The Georgia O'Keeffe Foundation/Artists Rights Society (ARS), NY: Digital Image © The Museum of Modern Art/Licensed by SCALA/Art Resource, NY; **Claude Monet, "Blue Water Lilies"**: Erich Lessing/Art